ANISH KAPOOR

FLASHBACK

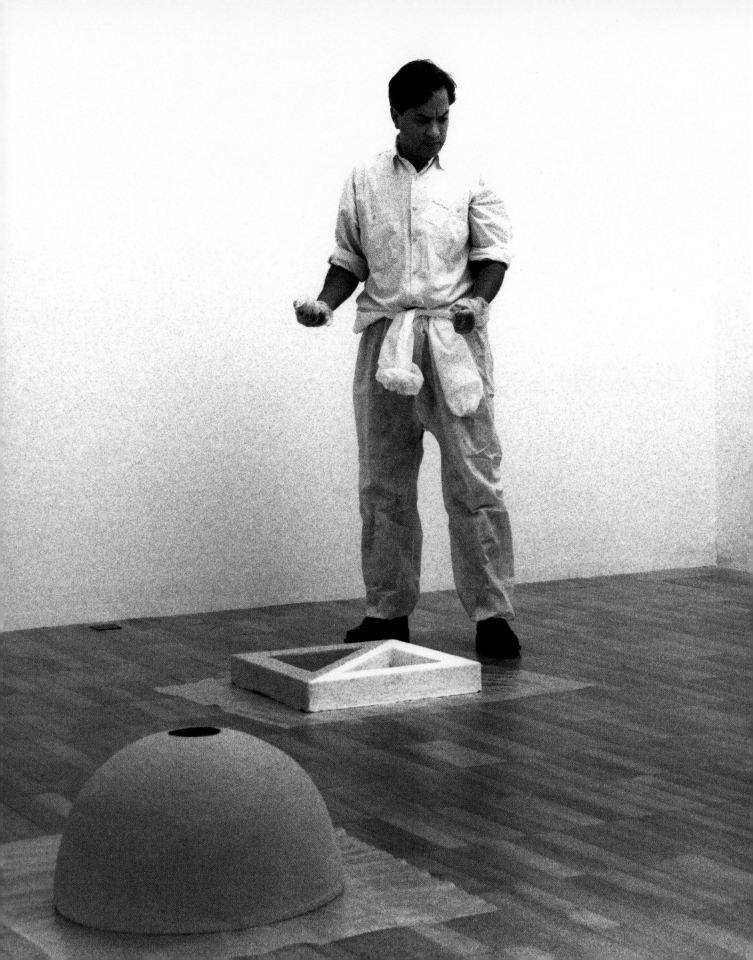

ANISH KAPOOR
FLASHBACK

Michael Bracewell and Andrew Renton

Published on the occasion
of the exhibition

ANISH KAPOOR: FLASHBACK

Manchester Art Gallery
5 March – 5 June 2011

Sculpture Court, Edinburgh College of Art
Edinburgh Festival, Summer 2011

Nottingham Castle Museum and Art Gallery
19 November 2011 – 11 March 2012

Longside Gallery, Yorkshire Sculpture Park
16 June – 4 November 2012

Exhibition curated by Caroline Douglas
and Natalie Rudd with the assistance of
Ruth Gooding and Lizzie Simpson

Exhibition at Manchester Art Gallery
supported by Investec Specialist Private Bank

Specialist Private Bank

Published by Hayward Publishing
Southbank Centre
Belvedere Road
London SE1 8XX
www.southbankcentre.co.uk

Art Publisher: Mary Richards
Publishing Co-ordinator: Faye Robson
Sales Manager: Deborah Power
Catalogue designed by Philip Lewis
Printed in Italy by Graphicom

A catalogue record for this book is
available from the British Library

ISBN 978 1 85332 288 4

This catalogue is not intended to be used
for authentication or related purposes.
The Southbank Board Limited accepts
no liability for any errors or omissions that
the catalogue may inadvertently contain.

Distributed in North America,
Central America and South America
by D.A.P. / Distributed Art Publishers, Inc.,
155 Sixth Avenue, 2nd Floor,
New York, NY 10013
T +212 627 1999
F +212 627 9484
www.artbook.com

Distributed outside North, Central
and South America
by Cornerhouse Publications,
70 Oxford Street, Manchester M1 5NH
T +44 (0)161 200 1503
F +44 (0)161 200 1504
www.cornerhouse.org/books

Cover: *Untitled* 1995
Back cover photo of Anish Kapoor
by Dennis Morris, 1998
Frontispiece: Anish Kapoor, 1996
Photo: Gautier Deblonde

Photographic Credits

Unless otherwise stated, all images have been
supplied by the Anish Kapoor studio.

Photographs by:
Philippe Chancel p.6; Kirstie Handley pp. 8–9;
Dave Morgan pp. 10, 18–19, 25, 26l, 26r, 31, 32l,
32r, 33, 34, 46–7, 54, 55, 56, 57, 58, 60, 81b, 84,
87r, 91r, 94l, 95; Andrew Penketh p. 14; Susan
Ormarod p. 16; Gareth Winters p. 17; Attilio
Maranzano p. 20; Mahendra Sinh pp. 22–3;
John Riddy pp. 27, 48–9, 68, 86, 88–9; Anish
Kapoor pp. 28–9, 63, 64; Walter Mitchell p. 30;
Larry Lamay pp. 40, 41; Nic Tenwiggenhorn
pp. 42–3, 44–5, 87l; Jussi Tianen pp. 52–3;
Markus Tretter p. 59; Gareth Winters pp. 65l, 66;
Gautier Deblonde p. 65r; John Edward Linden
pp. 67l, 67r; Mathias Schormann p. 69l; Peter J.
Schluz pp. 70–1; Prudence Cuming p. 77m;
Mike Hoban p. 92l; Billy Kiosoglou p. 94r;
pp. 36–7, 51, 76t, 76b Courtesy the Arts Council
Collection, Southbank Centre, London; pp. 79l,
79r Courtesy Government Art Collection (UK).
Photo © Crown copyright; p. 83 © Anish
Kapoor/V&A Images, Victoria and Albert
Museum, London; p. 88–9 Courtesy Hayward
Gallery, London. Photo: John Riddy

CONTENTS

FOREWORD

In 1982 the Arts Council Collection purchased Anish Kapoor's *White Sand, Red Millet, Many Flowers* (1982) from the Lisson Gallery in London. The advisors to the Collection at the time were artists Prunella Clough and Malcolm Hughes and critic John McEwan. Margaret Thatcher was Prime Minister, unemployment hit three million and Ridley Scott's *Blade Runner* was released in cinemas. In the intervening twenty-nine years the sculpture has time-travelled through seismic changes in this country, both in the art world and politically, and it has been exhibited in twenty-five different museums and galleries both in the UK and overseas. It is one of the most well known and best loved works in the Collection.

This is the second in the *Flashback* series of exhibitions from the Arts Council Collection, which celebrates some of the greatest acquisitions of work by young artists who have gone on to establish huge international careers. Rather than wait for time and other institutions to lend endorsement to an artist's work, the Collection has always relied on the advice of a changing roster of experts to identify when extraordinary work is being made. Anish Kapoor has acknowledged that *White Sand, Red Millet, Many Flowers* is a work he returns to time and again; it is testimony to the power of the work to act as a touchstone for a particularly electric moment in his development as an artist — that sudden, possibly unexpected coming-together of formerly inchoate concerns, intellectual and aesthetic, in resolved form.

Flashback traces a path from this revelatory moment to the present day. With great concision, works have been selected to map the evolution of Kapoor's art in such a way as to give clarity to the continuities that emerge. A concern with

colour and materiality, which has always related so closely to the intimacies of the human body, has moved from the abstraction of primary colours to an oozing of red, pigment-saturated wax that vividly recalls spilling viscera. A philosophical concern with the dualities of being and nothingness that was first translated into ample domes and hollows has played out through the fathomless depths of pigmented voids, or reflecting surfaces that morph reality.

In some respects the exhibition charts not only the development of Kapoor's career, but his relationship to this country. In 1982 he was artist in residence at the Walker Art Gallery in Liverpool and the period of free experimentation allowed by that residency is represented here by the wonderful *Red in the Centre* (1982), generously loaned from National Museums Liverpool. Bradford Museums and Galleries have loaned the mesmerising *Turning the World Inside Out* (1995), which is surely one of the jewels of their collection, and the British Council and Tate have loaned large-scale and emblematic works that, alongside works coming directly from the artist's studio, tell the story so far. We are equally delighted to be bringing the exhibition to Nottingham, where Kapoor's *Sky Mirror* (2001) was one of his first public sculptures in Britain and has been a permanent feature outside the Playhouse theatre ever since.

A number of people have made important contributions to the success of the exhibition, and I should especially like to thank them here: Andrew Renton's conversation with the artist, undertaken very shortly before the exhibition opened at its first venue, gives an invaluable insight, while Michael Bracewell's essay is a fascinating meditation on the wider themes and concerns that have preoccupied

Kapoor throughout his career. Our sincere thanks go to Lucy Adams, Clare Chapman and Peter Lynch at the artist's studio for their efforts in every aspect of the show. Natalie Rudd, Sculpture Curator for the Collection, assisted by Ruth Gooding and Lizzie Simpson, has spent many months meticulously planning and organising the exhibition, as well as being central to the shaping of this very beautiful publication.

Such is the complexity of presenting this ambitious survey of work by Anish Kapoor that the project has been very much a collaboration with the three tour venues. I should like to thank our colleagues at Manchester Art Gallery, particularly Tim Wilcox, Principal Manager: Exhibitions and Natasha Howes, Curator: Exhibitions, for their dedication and attention to every detail. At Edinburgh, particular thanks go to Sorcha Carey, Director of the Edinburgh Art Festival, as well as to colleagues at Edinburgh University and Edinburgh College of Art. In Nottingham, we thank the exhibitions team at Castle Museum and Art Gallery led by Deborah Dean, Visual Arts and Exhibitions Manager. We also thank our colleagues at Yorkshire Sculpture Park for their ongoing collaboration through the programme at Longside Gallery and for their proactive support of this exhibition. Mary Richards and Faye Robson in Hayward Publishing, along with designer Philip Lewis, have been remarkable in bringing together the vision of the team in this wonderful book, which provides a lasting memory of the exhibition.

And finally, our greatest thanks must go to Anish Kapoor, whose work and ideas will no doubt continue to fascinate us for many years to come.

Caroline Douglas
Head of Arts Council Collection

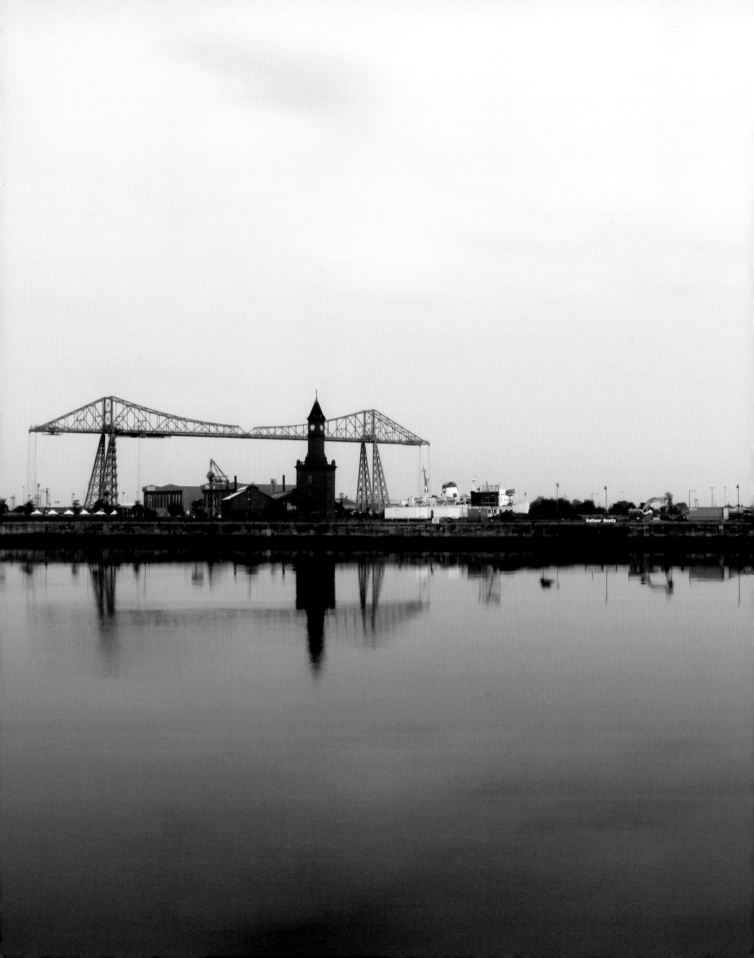

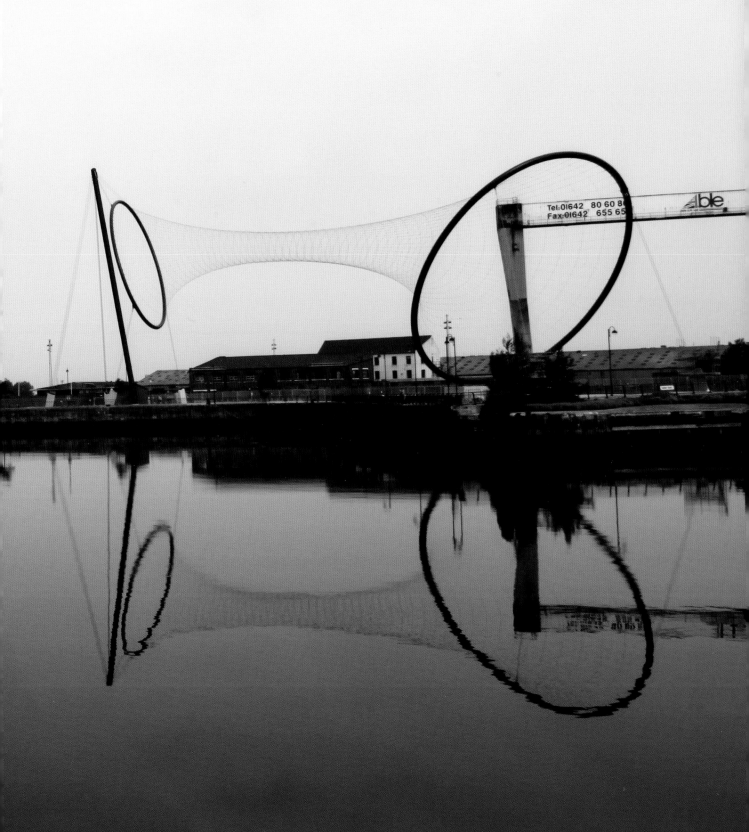

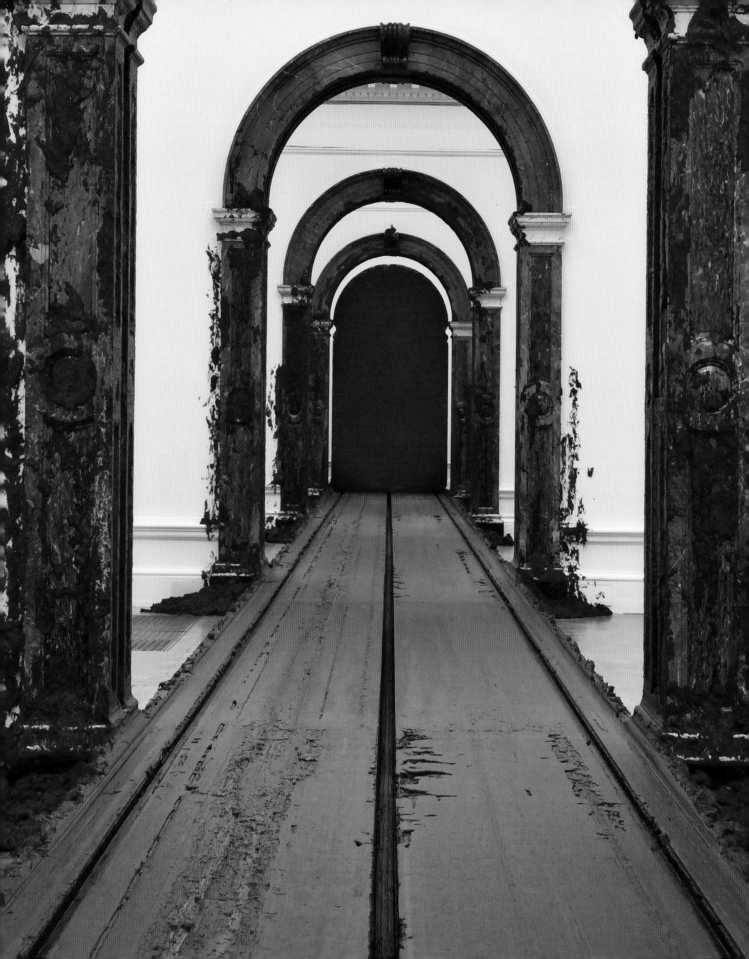

MATERIAL MEANS

An introduction to the art of Anish Kapoor

Michael Bracewell

'Form has a propensity
to meaning. And meaning
is the translation of art.'
Anish Kapoor[1]

The viewer's first impression is of intense presence: majestic,
somewhat ceremonial and portentous. It is an aura common
to sacred sites and also to nature: its quietude is resonant with
expectation and mystery; stilled yet alert, it is suggestive of a portal
to a heightened state of enlightenment somewhere beyond. One
thus approaches the art of Anish Kapoor with a richly visceral
feeling of being drawn into a gravitational field. The experience is
at once thrilling and meditative: the body is both moved and held
in space; the intellect is engaged and calmed. From its scale, colour,
form and tactility, each work refines a seemingly sentient identity,
sharing the confluence of harmony and timelessness.

Kapoor's art strikes the viewer first with its immediacy. It is
mesmeric and spectacular: a visual and virtual force that enables
and enhances a profound individual response. The sculptural object
– whether resolved to near primal intensity or, more often, left
indeterminate or ambivalent in some way – achieves a generosity
of spirit that guides the viewer towards a better understanding of
human consciousness and his or her own deep subjectivity. In one
sense, therefore, the work might be seen as being like certain kinds
of music, for it transposes form and colour, scale and material
into their conceptual and philosophical equivalents – nameless,
unknowable, yet intensely present as matter.

Each of Kapoor's works, however discreet or monolithic,
creates a monumental intervention into the linearity of time and
the passage of consciousness. We might describe this intervention
as a pause, or gap, within which the viewer is offered sanctuary and
raised awareness of one's physical situation: an opportunity within
the quotidian to suspend one's oscillation between memory and
anticipation, and to experience self-consciousness within the here

Svayambh, 2007

and now. In engaging with the senses and intellect in this way, Kapoor's art thus reveals, in epic terms, the continuum of sentient perception. He renders the material into immateriality and the immaterial into matter: the dimensions and media of each sculpture translate into paradigmatic vistas of infinity and invisibility, occasioning each viewer the opportunity to reflect not on the imaginary or the esoteric, but upon the realities of existence.

Throughout the first half of the 1980s, he made a succession of works from pigment and mixed media – the *1000 Names* (1979–85) series, for example (p. 15) – that were usually made up of several sculptural objects placed directly upon the gallery floor. The visual drama of these works is intensified by the manner in which their curved, sharp, ovular, rounded or geometric forms seemingly dissolve around their edge or base into a surrounding spread of powdery pigment. It is an effect that is visually pleasing – as though satisfying some correlation between the optical and tactile – and suggestive of organic states of permanence and impermanence: the materiality of matter and the fluidity of process and form.

White Sand, Red Millet, Many Flowers (1982, pp. 36–37) comprises four sculptural objects placed upon the gallery floor in a close configuration. The impression might be of a miniaturised and somewhat fantastical mountain landscape, or of mounds of substance displayed in a raw state. The viewer is swiftly absorbed by the optical/tactile contrast in the work. Two of the objects are soot black; one is bright primrose yellow; and the last and tallest is a vivid and declamatory red. Kapoor's iconic use of colour creates an effect that is as tactile as it is visually hypnotic. This is colour in its most pure, intense and elemental form – joyous, primordial and eschewing aesthetic *politesse*. Indeed, it is a work about pure

colour: the red and yellow create a dazzling contrast that is further sharpened by the powdery blackness of neighbouring elements.

White Sand, Red Millet, Many Flowers appeals directly to the senses of the viewer, liberating form and colour into an exuberant and beguiling assertion of themselves that appears to be free of aesthetic or art-making systems. The longer one looks at the sculpture, the purer in conception and more visually engrossing it becomes – in particular, perhaps, the space between the objects draws one in. In sculptural or diagrammatic form, the work enables an occasion for transcendence beyond the present forms – the Sublime rerouted through pure abstraction. This latter attainment, evoking awe, wonder and mystery, is a common denominator of the art of Kapoor.

Made in the same year, *Red in the Centre* (1982, pp. 38–39), the first of a series of works made with earth, appears to extend and enhance the abstraction of *White Sand, Red Millet, Many Flowers*, but here the five objects of the work possess a more animate, sinister presence, further charged by the contrast between bone- or stone-coloured elements and the use of visceral blood-red pigment. The elements of this work bring to mind the organic forms of the natural world and artefacts from indigenous cultures: pods, bones, altars and ceremonial-ritual artefacts. There is also a forceful sense of sexual and gender-related symbolism, and of the duality of male/female identity as an eternal pattern. The latter dichotomy highlights how the play of binary oppositions and contrasts of various kinds – solid versus evanescent; virtual versus visual; interior versus exterior; optical versus tactile; positive versus negative; whole versus fragment; object versus non-object – are not only fundamental to the grammar of Kapoor's art, but also the very

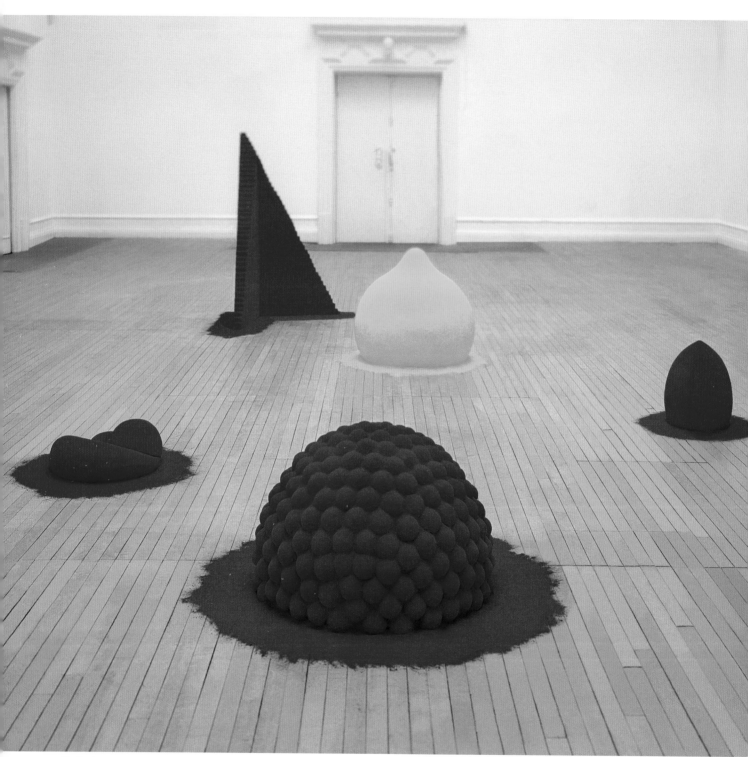

To Reflect an Intimate Part of the Red, 1981

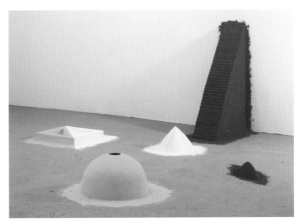

1000 Names, 1981

method by which his work, like all language, generates meaning through difference.

Simplicity of form and complexity of idea, and the artistic formulae relating surface and depth, are of paramount importance. One might therefore liken the transcendence in Kapoor's sculptures to the grand sweeps of nature, when a mountain lake, for example, exists equally as a simple and spectacular phenomenon – revealing its multi-layered complexity in its own 'language' and at its own speed. A later work, *Void* (1994, pp. 46–47), affirms the way in which this relationship between simplicity and depth, known and unknown, is made eloquent. The halved and hollow cone, coated in the iconic, vivid blue pigment that has become a signature in his art, is a simple yet highly evocative form that is richly responsive to the fall and play of light. The internal depths of the blue cone become forcefully representative of both outer and inner space. They possess a mystery one might associate with the movement of light upon distant planets; at the same time, they appear to be emblematic of consciousness. Kapoor creates a meticulous and aesthetically confrontational balance between scale and effect, visibility and invisibility. The concision within his work suggests vastness, anticipating the spectacular qualities of his larger and site-specific sculptures.

The titles that Kapoor gives to his works are at once poetic, descriptive and suggestive of the feelings and themes that the art brings to life. *Void*, for example, becomes, in relation to its work, a title laden with meanings, while also alluding to the cosmic and sculptural capacities of emptiness and nothingness – states that might be interpreted as blissfully resolved, even death-like, as they evoke profound inner peace. The blue of the piece is darkened

within its interior by shadow, and thus brings to mind the voids of deep space, underground caves and the depths of the ocean. Throughout the art of Anish Kapoor, there is the notion, dramatically manifest, that the physical world is synonymous with, and reflective of, the spiritual condition – that the sculptural object conveys a state beyond its actual form. That said, every one of his works remains first and foremost a *sculpture* – that is, it says to the viewer, as Kapoor has put it, 'Come over here. I can engage you deeply and my space will infiltrate yours.' Accordingly, these voids assert themselves above all on the viewer's *body*; their effect is primarily physical, material, causing a sense of vertiginous disorientation. Whether groups of small powdered forms, or human-sized stone slabs, or monumental mirror pieces, or blood-red wax and Vaseline structures that fill or squeeze through architectural spaces, such as *Svayambh* (2007, p. 10), Kapoor's sculptures create a heightened awareness of the shape and scale of one's environment and one's place within it – and it is in this physicality, this correspondence between sculptural object, urban form and spectator, that one finds the works' principal significance and function as sculpture. As Homi K. Bhaba has written in respect of Kapoor's art, 'For an abstract artist, the phenomenological structures of experience revealed in the everyday enactments of urban life are of fundamental importance in the understanding of "scale", "shape", "objecthood", "skin" and "colour".... The temporality of everyday, urban spectatorship is a crucial element in the disclosure of meaning.'[2]

The upright sandstone block, inset with an oblong of blue pigment, entitled *Adam* (1988–89, pp. 40–41) possesses a mythic and apocalyptic aura. This 'pillar' has an industrial and archaeological quality, while the inlay of blue pigment creates an impression of

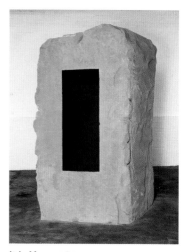

It is Man, 1989–90

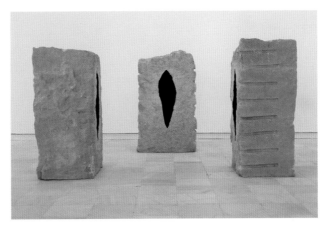

Three Witches, 1990

sanctity. Kapoor's use of stone (limestone, sandstone, slate) evokes the forces of the natural world. Rough hewn into slabs and blocks, these stones assume alternate purpose or significance: they seem to assert time and eternity, while suggesting simultaneously active life and the sense of being prehistoric in execution. As such, these works take on an epic quality, as though representational of archetypal figures and conflicts from ancient histories. *Three Witches* (1990) and *It is Man* (1989–90) take their place alongside *Adam* as works created from sandstone and pigment; while works such as *Void Field* (1989, p. 66) also establish the development of this major strand within Kapoor's artistic language. Pigmented openings and fissures in the stone create a suggestion of covert meaning and religious function – the effect is also cold, alien and touched with portentous mystery.

The mysticism and ritual of sexuality and gender run through Kapoor's art, as much as the shapes and materiality of the physical world. Seemingly simple inversions and reversals of contour enable the artist to create powerful sculptural interventions – the effects of which appear to invest their media or context with renewed sentience. *When I am Pregnant* (1992, pp. 42–45), described by the artist as 'an object in a state of becoming',[3] is such a work, comprising a natal 'bump', implying reproduction and birth – further personalised by the first person singular of its title. The 'whiteness' of *When I am Pregnant* also connects its visual language to a series of works Kapoor made throughout the 1990s and early 2000s (notably the *White Dark* series) that explore whiteness, ovular shapes, hollows and shadow.

The pristine, cool smoothness of these works stands in stark contrast to the rugged stone and rich blueness of the preceding

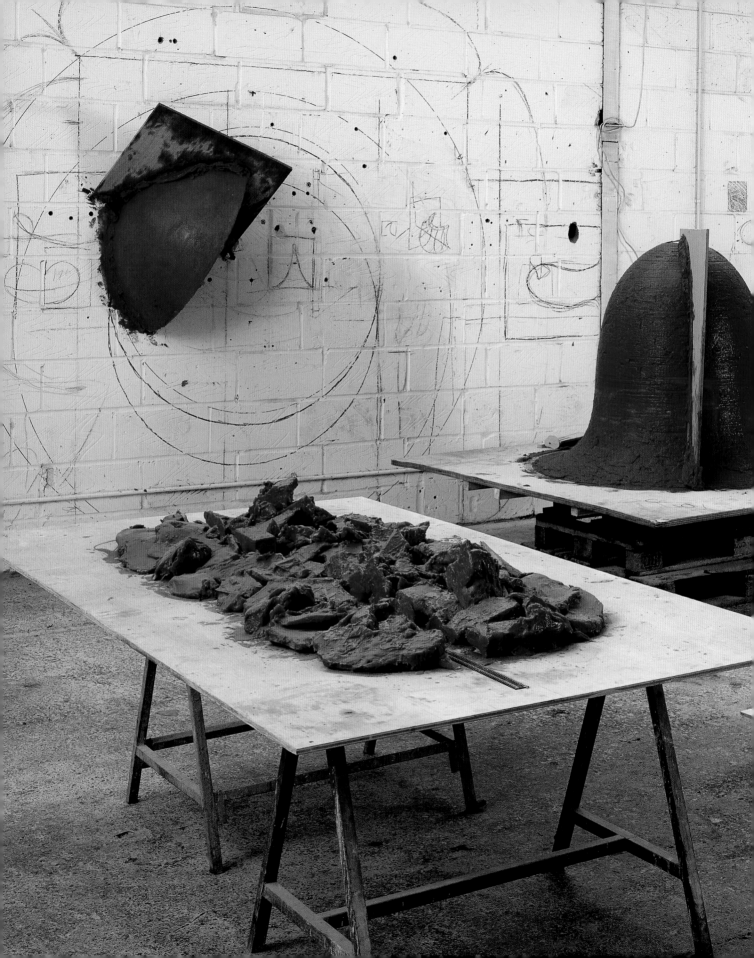

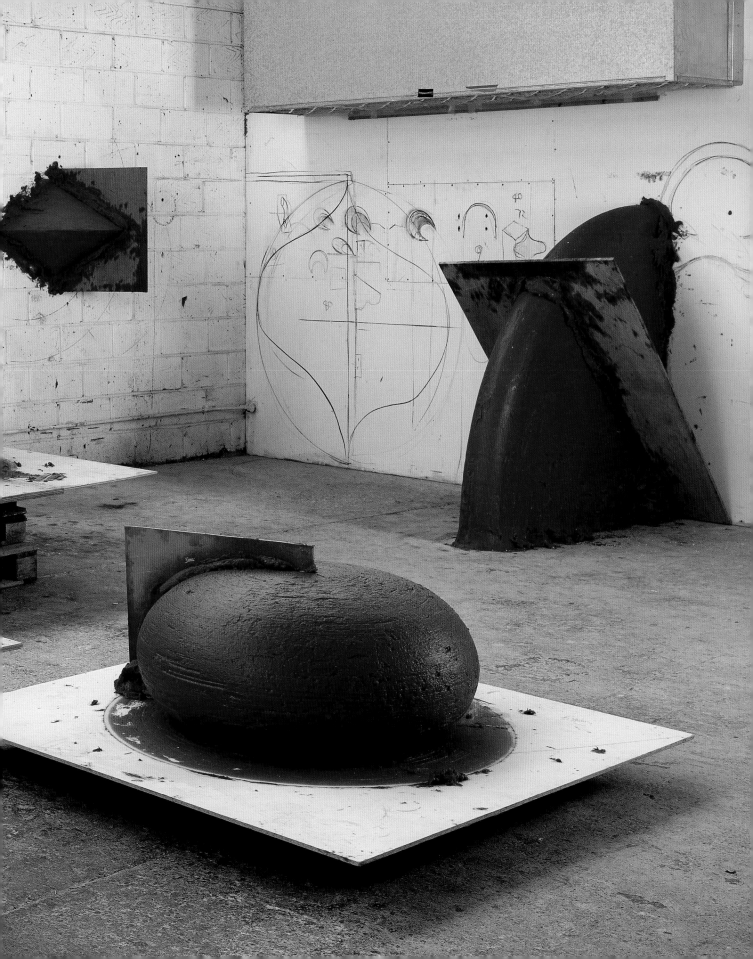

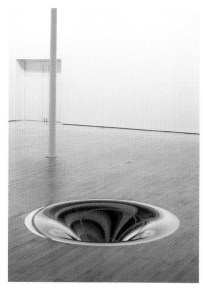

Turning the World Inside Out II, 1995

period. Just as there is a holistic quality to Kapoor's practice, in which the interrelationship of ideas, shapes and materials is in constant development, so the movement in his work from blue to white, and from rough hewn to smooth (and more recently, with the wax *Negative Box Shadow* and *Moon Shadow* (both 2005, pp. 54–57) and the *Between Shit and Architecture* concrete pieces (p. 31), back to rough again), appears to renew his career-long engagement with tactility, colour and form. One might also see a shift from 'male' archetype to its 'female' counterpart – reflecting the notion of gender balance within the natural world. *When I am Pregnant*, as much as the other 'white' works from the 1990s, asserts the universality of opposites by evoking the contrasts of darkness and light.

One could say the art of Anish Kapoor has developed through a series of self-transcending cumulative progressions of this kind – each phase of work advancing and consolidating that which has gone before. In his works made from stainless steel, he pursues forms that have already begun to yield their sculptural and mystical capacities. *Turning the World Inside Out* (1995, pp. 48–49) comprises a cast stainless-steel sphere, the reflective surface of which achieves the effect described by the work's title. By engaging in such an immediate and dramatic manner with the possibilities and visual impact of reflection and mirroring, Kapoor advances the correlation between sculpture and spiritual technology – meditation and psychological 'reflection' – that has always been a major theme within his art.

Once again, the depth of surface is vital to the manner in which *Turning the World Inside Out* and such works as *Untitled* (1995, pp. 50–51) employs our fascination with reflection as a form of Socratic lure to draw the viewer into a deeper sense of engagement

with the work. In looking at the sculpture, we reflexively re-see our surroundings and context: the present moment is reaffirmed, held in place for consideration within the ceaseless flow of temporality. Mirrors affirm stillness and pause, thus acquiring in Jungian symbolism a direct affiliation with religion. (Etymologically, the word 'religion' derives from 'to consider carefully' and 'to reconnect' – both variants equating with the roles of reflection and mirroring as they are sculpturally manifest and empowered by Kapoor.)

While Kapoor has made monolithic 'mirror' works within rural, urban and architectural environments (see *Sky Mirror*, p. 91 or *Cloud Gate*, pp. 70-71), creating vast, vertiginous possibilities for reflection and the reseeing of surroundings and context, *Her Blood* (1998, pp. 52–53) might be seen as an intense, piercingly refined chamber version of these grand visual symphonies. Three large mirrors are placed in a triangular configuration within the gallery, with two 'clear' mirrors facing a third, blood red in colour. In keeping with the themes of sexuality and archetype that run through Kapoor's art, the menstrual imagery in this work, proposed also by its title, suggests – but does not necessarily confirm – the duality of gender.

The grandeur of feeling and questioning in his work derives from its evocations of wonder and mystery, preferring to open a possibility rather than endorse a statement. In this, the art of Anish Kapoor – at once monumental and minutely poised ('to have squeezed the universe into a ball', writes T.S. Eliot, 'to roll it toward some overwhelming question'[4]) might be seen as affiliated to the emotional journeys of religion and faith. It is an art concerned with knowing and with not knowing: with the passage of presence between the unseen and the visible – transcendent, sublime, cosmic and terrestrial.

1 Anish Kapoor, in Adam Lowe, Simon Schaffer and Anish Kapoor, *Anish Kapoor: Unconformity and Entropy*, Madrid, 2009.

2 Homi K. Bhaba, 'Elusive objects: Anish Kapoor's fissionary art', in Homi K. Bhaba, Jean de Loisy and Norman Rosenthal, *Anish Kapoor*, exh. cat., Royal Academy of Arts, London, 2009.

3 Anish Kapoor, in 'Mythologies in the Making: Anish Kapoor in Conversation with Nicholas Baume', in Nicholas Baume (ed.), *Anish Kapoor: Past, Present, Future*, exh. cat., Institute of Contemporary Art, Boston, 2008, p. 47.

4 T. S. Eliot, 'The Love Song of J. Alfred Prufrock', London, 1917.

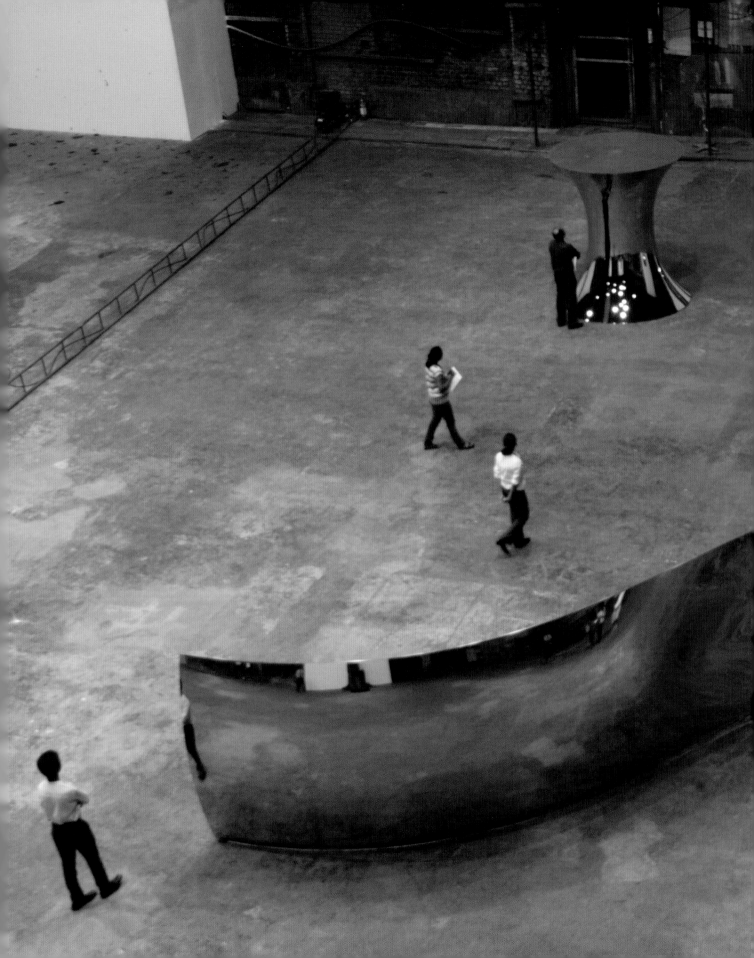

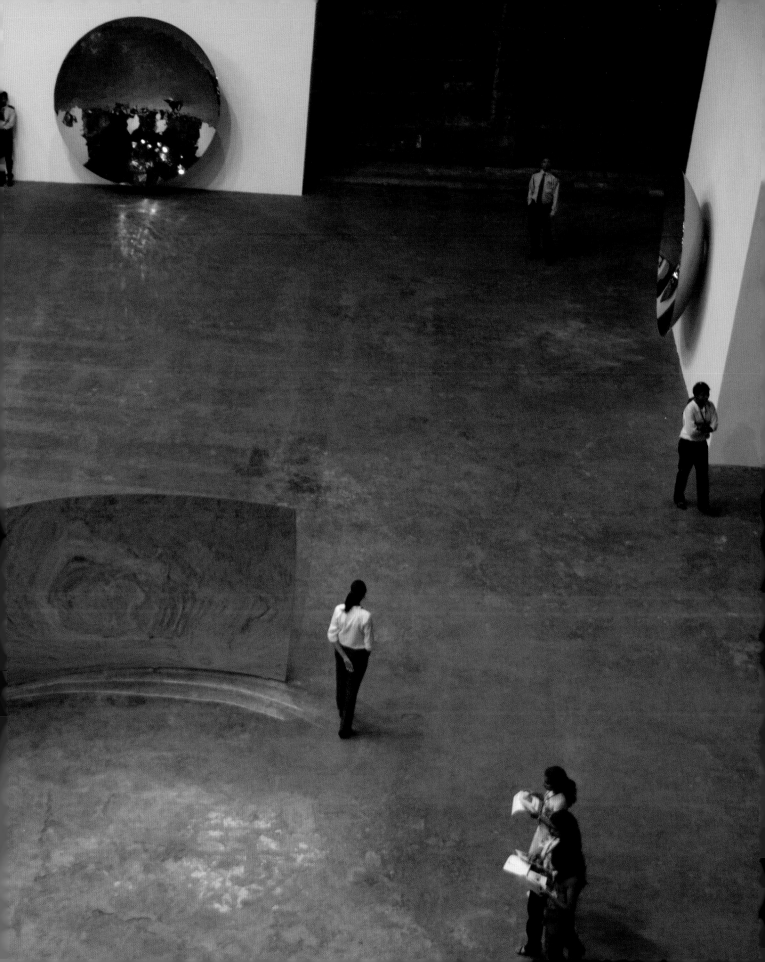

ANISH KAPOOR IN CONVERSATION WITH ANDREW RENTON

AR You have just returned from India, where you had two major exhibitions, one in Mumbai and another in New Delhi.

AK Yes, it was a curious sort of home-coming, very important for me and great fun too.

AR Seeing the incredible attention generated around the two shows made me think about both the future – because there are new works in the ambitious installation in Mumbai – and the past, because of the older pieces in the New Delhi retrospective. It started me thinking about the very early works, such as *White Sand, Red Millet, Many Flowers* (1982), and how a certain kind of form is associated with you as someone coming out of an Indian culture.

AK I've always been very reticent about that association. In a way, these early works are perhaps more Indian than some of what has come after them. Nonetheless, I think there's a certain philosophical continuum. Nowadays it's fashionable for artists to mine the exotic route. But my feeling is that the great historical pulse doesn't come from that, that it is almost a side issue. The questions at the centre are still in the avant-garde. Even though the avant-garde itself may not be what it used to be, there is a formal innovative process that is contemporary and isn't linked to a sort of historicist, exotic, personal psychobiography or whatever it is.

AR So is it fair to say that modernisms sometimes hit different places in different ways and get mangled up a bit?

AK Correct.

AR And they get reconstituted, returning back to you in changed forms.

AK I think that's the way to look at it, rather than the alternative which says, 'I come from Japan, and in Japan we have this particular ceremony which does this.'

AR It wouldn't work with you anyway. There are all the other sides to your own background, your own interests, and your own histories. Those histories are just points of intersection, rather than necessarily being the absolute point of prevalence.

AK Which is why I've felt that my interaction with Homi Bhabha has been so fruitful. Homi comes from a similar background to mine, and his post-colonial view is not unrelated. But the longer we look at it, the more we see that your personal perspective is not that different from mine. It doesn't matter where you come from in the end.

AR It's about a memory of journeys, rather than carrying a fixed set of identities.

AK I think the whole conversation has become much more sophisticated and one is able to say, 'Okay, so there are some Indian bits and they're quite important.' Clearly, my colour sensibility is partially informed by that.

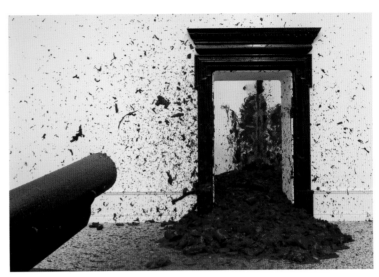

Shooting into the Corner, 2009

AR But not just at an aesthetic level? When we look at the early works with the pigment, there's a materiality to it. I've heard you say that colour is stuff. There's a thing-ness to colour. It's not necessarily that one would *interpret* colour.

AK No. I'm not talking about interpretation. It's stuff. I'm also deeply drawn to colour as some kind of alchemical dark matter.

AR It feels with recent works like you've solved on a massive scale what you set out to do more modestly in the early 1980s: the thing-ness of colour. I think one lasting memory of your Royal Academy show in 2009 is red – a bit of yellow, some blues . . . but above all red. And there's something extraordinary about the materiality there. It feels like there's been a very long journey to get to it.

AK I think of Judd, of course, and the way those works he made throughout his life bring colour *into* the space. There's a particular work in the Tate collection that

is perhaps almost singular in being, a complete monochrome: *Untitled* (1972). Monochrome in space is really interesting because it eschews composition. It says 'No more composition – only immersion, no composition.'

AR We were just looking at one of your earth paintings. It's interesting to think about it in relation to all of *that* history, because it's not a monochrome. It knows how to speak monochrome – it's learnt the language – but it's not monochrome. I think back to the shock to my system when I went to Russia and saw Kasimir Malevich's *Black Square*; it turns out it's not black and it's not square.

AK Exactly!

AR And it's the same with Robert Ryman, who *does not* paint white paintings. So there's this kind of nuance constantly. There's a piece in this show that plays with monochrome, *Adam* (1988–89). There's a monochrome set inside what

looks like a sculpture, but this is the moment in your work where you start to worry less about the edges. That's the thing I'm grappling with now. I think you've solved so many problems of the formal because you materialise things, but you've also undone the edges of those things, and that's been an ongoing negotiation. Whether it's *Svayambh*, which we saw at the RA, or the *Orbit*, or here with *Adam,* it feels to me like a different relationship to the object. Where am I meant to be looking in terms of this very particular thing? There's a push–pull where I negotiate the sculpture with my body, but you're saying to me, 'That's not enough.' You're saying, 'I want you to lose yourself a little bit here inside the object.' So I experience this weird thing where I have a sense of mass but I can't quite assimilate the object. It's not like Richard Serra in that sense.

AK No, it's not like Richard Serra. It's an important juxtaposition because one of my fantasies about the object is that

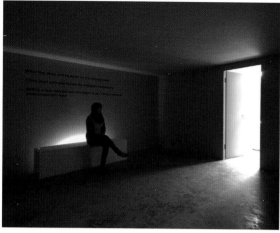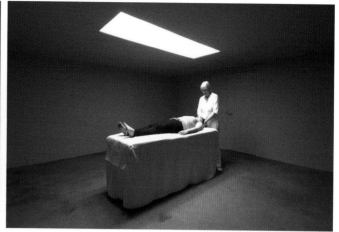

Imagined Monochrome, 2009

there's always a non-object; that there's always a parallel. And, interestingly, modern physics seems to say that there is too.

AR So there's a parallel universe?

AK Yes, but of course it's a very romantic view of the object to say that it isn't fully present, that it isn't just here. But now that physics seems to say that that may actually be true, at one level anyway, it pulls it out of romanticism. In other words, it doesn't become pictorial. So there is this curious relationship between the pictorial object and the physical object. That's what I've always been really interested in: that the object lives in these two parallel spaces.

AR And the mediation is through me. Me and my body.

AK No question. I think it must have to do with the idea that we pictorialise our interior. At some level, our interior is too

ephemeral, but when I picture myself, I picture a kind of interior, some kind of something that isn't fully graspable, that's something *more* than the physical me.

AR You very often want to take your viewer into a kind of darkness, even a literal one; into a space that can't be fully determined, and part of the role of the work seems to be to take them there.

AK At the 2009 Brighton Festival, I made a work that was called *Imagined Monochrome*. You went into this room and there was a text on the wall that said you will get a massage and will see a monochrome. You go and lie down on a massage table and someone gives you a very perfunctory massage. Ninety per cent of people see a monochrome, and it changes colour as different parts of the head are massaged. The idea being that there is a mental object. It's very carefully set up, of course, because there are bright lights above your head.

AR So it's purely retinal?

AK It's retinal . . . but you do see a monochrome. It is an attempt to manufacture an invisible object, an imaginary object.

AR But doesn't that tell you that there's a desire for a very particular kind of art experience? There is a fundamental thing that we all dream of having, which is this encounter. And it's a very profound, sublime encounter.

AK Correct.

AR And it would seem that for us in a modern moment the monochrome is the thing that clarifies the space.

AK I think that's true. The monochrome goes to places images can't go.

AR I'm sorry I missed it! We were talking about the use of pigment, but of course the other material that you've used so often is the mirror and reflection. The

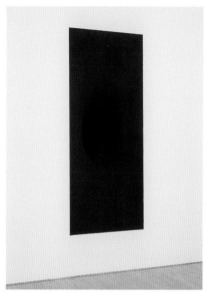

My Body Your Body, 1993

effect is very literal when it becomes mirror, even in a more complex configuration like the fractured or pixellated mirrors. It's very obvious what happens, of course; you get reflected back in it. But it's more than that. When you see yourself in the mirror, you have to 'unsee' yourself. You have to do something with your eyes to take yourself out of it, but you're still inside it.

AK I made void pieces for a while and they were more and more monochromatic. Spaces filled with monochrome. They were all hollow – they were full of dark red, dark blue, dark whatever. There's some perceptual thing that happens, which is that the edge acts in a very particular way. It's almost as if a kind of film forms across it, where you can't quite tell how deep it is. So it's as if the monochrome spaces come to be heavier, deeper, darker than the object that contains them. After doing that for a while, I felt I needed to go somewhere else, and I wondered what would happen

if it were a space full of mirror. So that's what I did. The first mirror pieces were mainly hollow, spherical forms, set into the wall, a space full of mirror. It's not a mirrored object – quite different from that. I became more and more interested in involuted forms. I'd been making them in pigment pieces of various kinds, as voids, for a number of years. So I made an untitled mirror piece in 1995 that is set into the wall and is a flat mirror with a sucked form in it. It's the same form as a void work from 1993 called *My Body Your Body*.

AR And what happens that's different?

AK Well, a space full of mirror does the same thing as a space full of dark monochrome. You get this foggy field across the 'aperture' of the object, and it is confounding; you can't tell how deep it is. The mirroredness, in the right conditions, concave mirroredness, does something to dematerialise the object. As a positive form, mirror camouflages

the object. We know that it picks up reflections of all sorts – whatever's around it. As a negative form, it doesn't just do that – it also includes space. It somehow catches the space, confusing what you look at. What is the space of this object? When they are properly made, at least, and that's the problem, they have to be made *very* well, and it's taken me too many years to make them well enough. In a concave form, the smallest aberration magnifies. So a small dent in the surface looks like a huge dent in the surface. The obsession with the well-made, on one level, drives me absolutely mad, because my impulse is often to do exactly the opposite: rough and ready, 'I don't give a shit, just make it!' So now I have these two sides of my practice.

AR You're trying to make it so well in order to unsee what that surface is.

AK That's right. You have to look beyond the object, and you also have to teach your public to look in a particular way.

Overleaf: Artist's studio, 1979

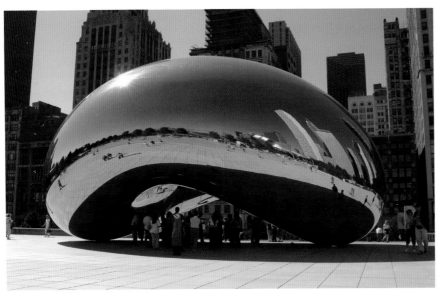

Cloud Gate, 2004

AR Last night I did an image search online for *Cloud Gate*, and I found this ridiculously well-documented object. Now that's a convex mirror...

AK Convex and concave in the interior.

AR What this search revealed is people's negotiation of the object. It's constantly about adjusting your sightlines. It's about putting yourself inside it, and it occurred to me that there was no way to represent, photograph, illustrate or talk about any of your mirrored pieces without context. It's not that they're context-dependent, just that they can't avoid their context.

AK Yes, that's right.

AR Having fully achieved the void in one series of works, you now achieve, in others, almost the opposite. The work absorbs everything around it.

AK Yes, it is on one level. At another level, I think it's doing very similar things.

I think again, it depends on which ones and how you look at them.

AR I was intrigued when we were looking in the studio at the next group of works after the *Greyman Cries, Shaman Dies, Billowing Smoke, Beauty Evoked* series you showed at the RA. When people first saw them, they were shocked. They didn't associate these cement pieces with you. It seems to be the return of the repressed. It's as if you've spent time perfecting things but now have said, 'I'm going to make some shitty looking things.' But the thing I'm excited about is that they are absolutely consistent with that great piece *Svayambh*. The meaning of its title – as we've learned from you – is 'self-generating'. These pieces are also self-generating. Is that what you've been working towards? The kind of object, the kind of art work, that makes itself? Where conditions are established, strict rigorous conditions, and very carefully worked through, but the object goes beyond you, goes beyond your limits as a sculptor?

Greyman Cries, Shaman Dies, Billowing Smoke, Beauty Evoked, 2009

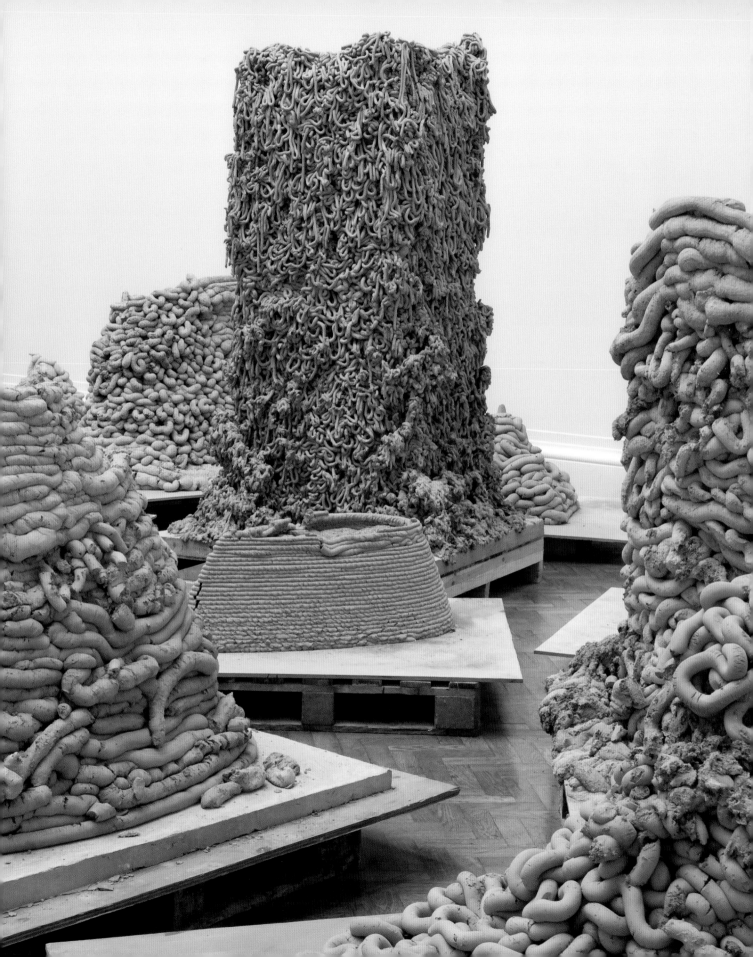

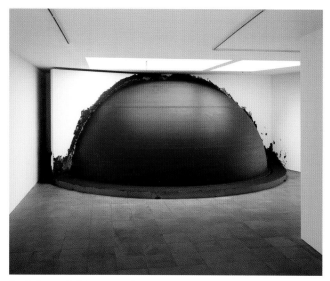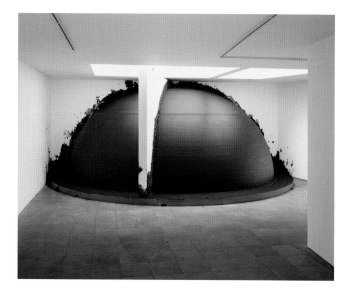

Past, Present, Future, 2006

AK Of course, both the object and the eye are incumbent. So the fiction of the object is that it isn't quite there. The other fiction is that the object isn't made. The object makes itself. And that's present for me in the pigment pieces in that they are iceberg-like. The form is defined by the pigment, but there's a kind of invisible object below. Of course it's a post-minimalist formal question. I want to make form in such a way that making is absent. It has utopian ideals, and therefore the hand of the artist is not needed. But take that a step further, and it's a self-made, auto-generated, auto-object. Over the years, and in many different ways, I've tried to look for this auto-object. The wax pieces have led me to very simple mechanised processes where it's wall moving through 180° that defines, because it's cut out, an object

or an object moving through architecture, as in *Svayambh*.

It's a fiction, of course. The fiction is the ability of an object to be other things than just the thing that it describes. I feel more able as an artist to let go of the meaning. Meaning happens, or the meaning can be there because of these layers of fiction, there are different kinds of meanings and they will be there simultaneously.

Some people say, '*Svayambh*, is about the Holocaust.' Well, it's one of the possible ways of looking at it. I'm perfectly happy with it. It's not what I set out to do however. Other people say, 'It's the post-partition trains coming from India to Pakistan', etc. Yes, but no. As far as I'm concerned, it's a formal proposition and of course, I chose a particular kind of red. One of the things I've had to do is abandon meaning. Let the process do what it does.

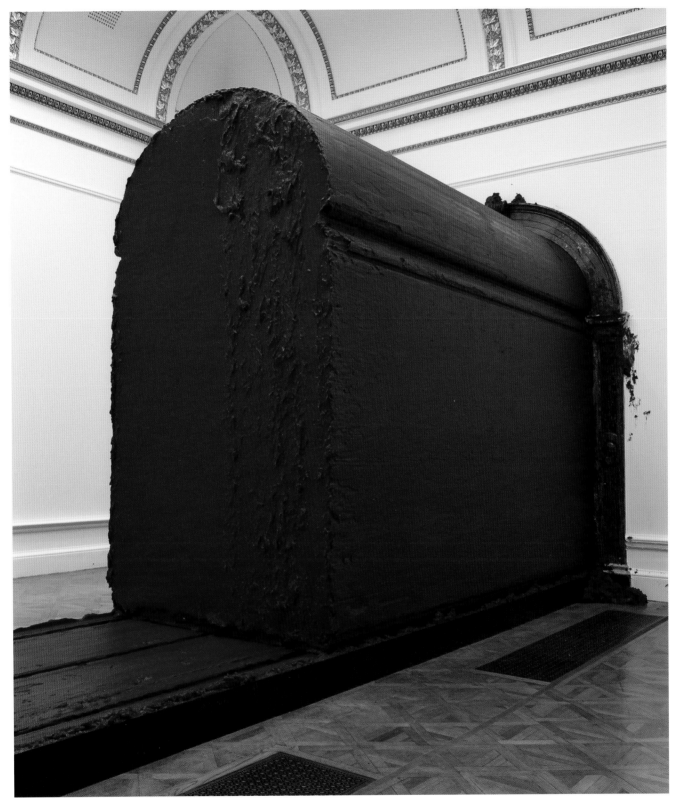

Svayambh, 2007

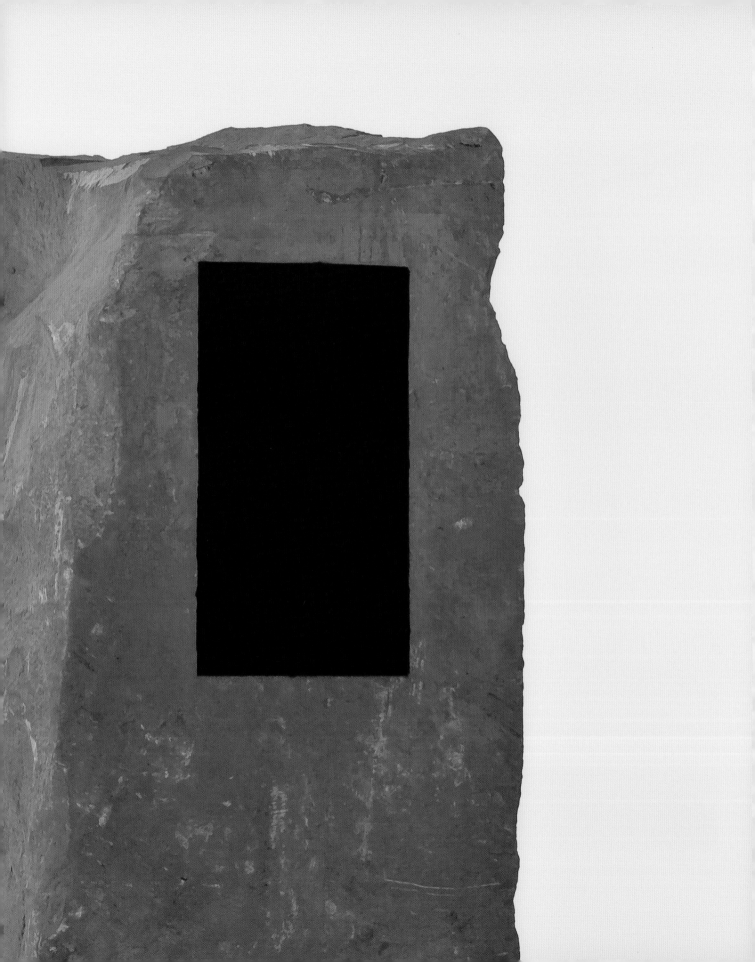

PLATES

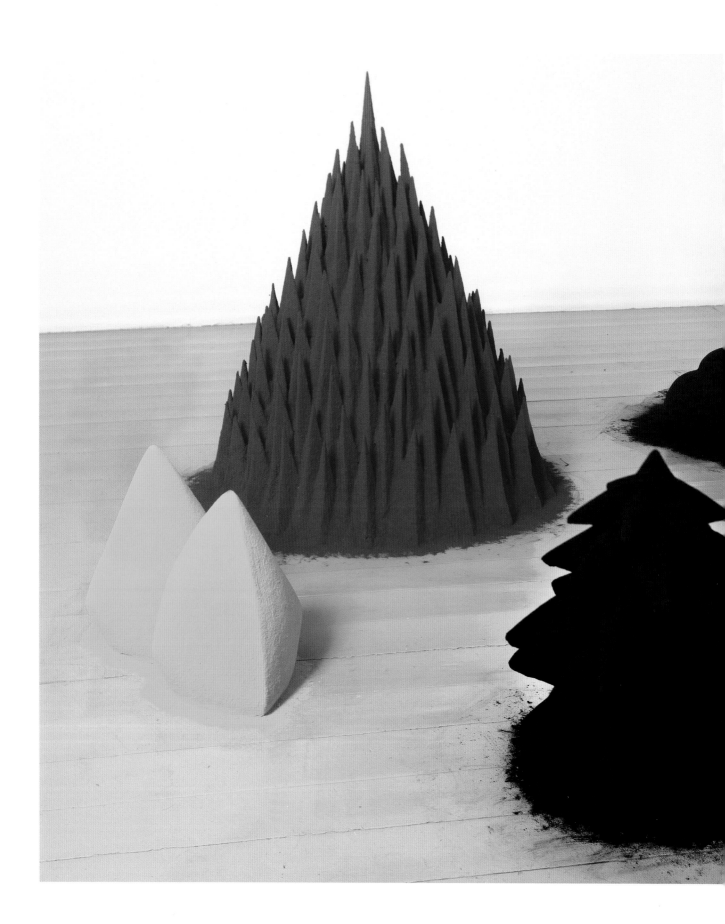

**White Sand, Red Millet,
Many Flowers** 1982

Mixed media and pigment
101 × 241.5 × 217.4
Arts Council Collection,
Southbank Centre, London,
purchased 1982

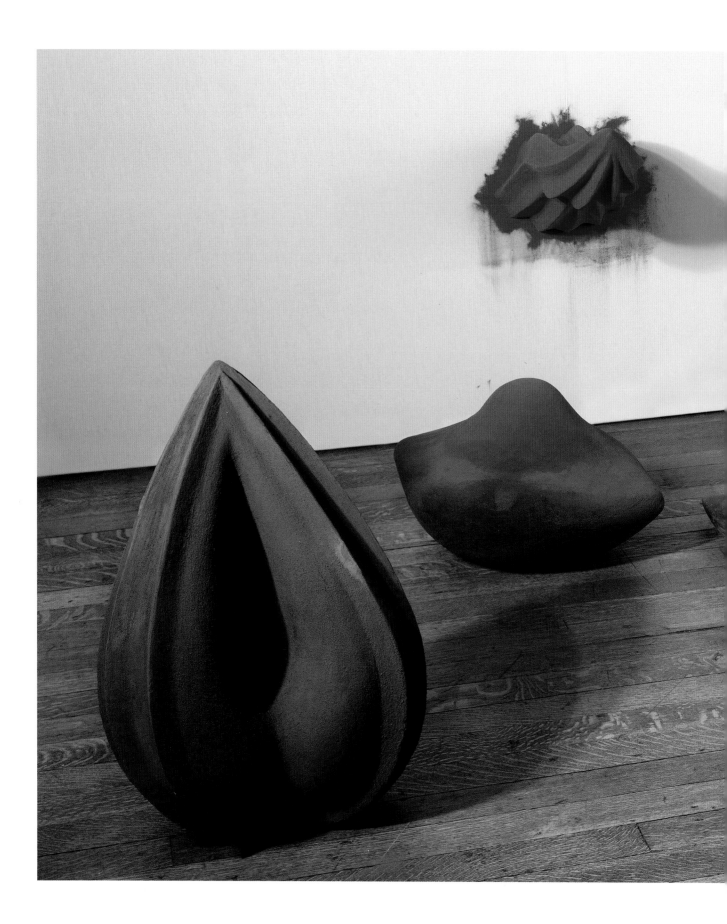

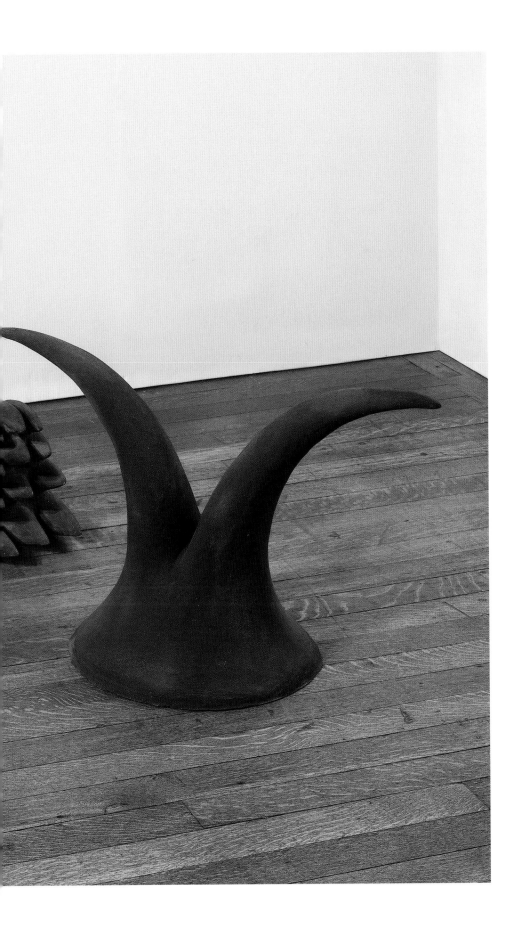

Red in the Centre 1982

Mixed media and pigment
Dimensions variable
National Museums Liverpool,
Walker Art Gallery,
purchased 1982

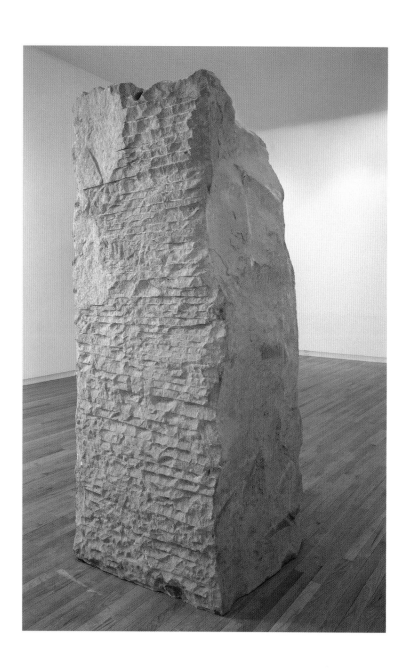

Adam 1988–89

Sandstone and pigment
239 × 120 × 104
Tate. Presented by the
American Fund for the Tate,
courtesy of Edwin C. Cohen
(for A., A., A. and J.) 2000

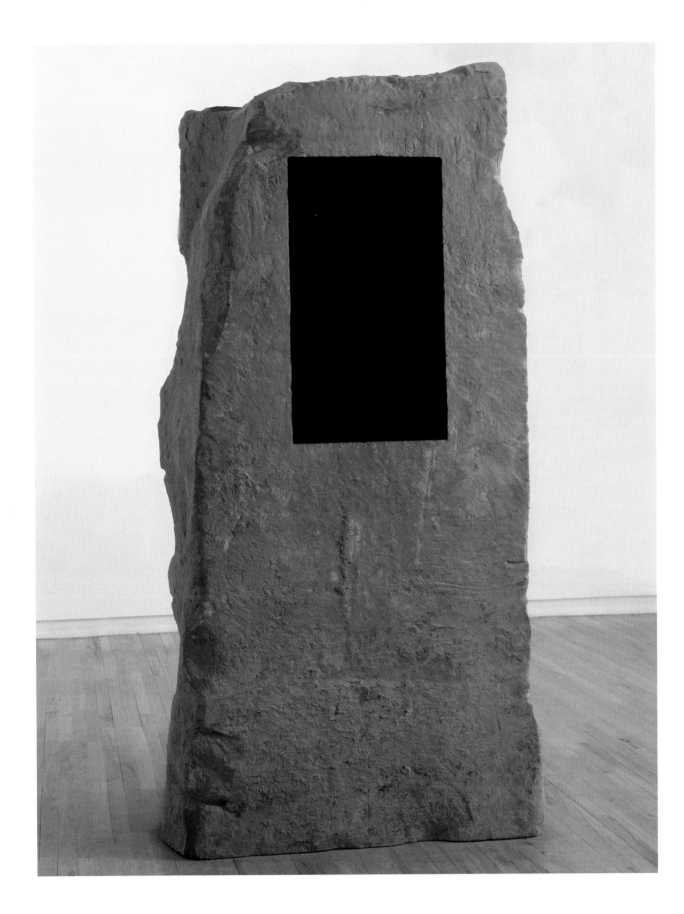

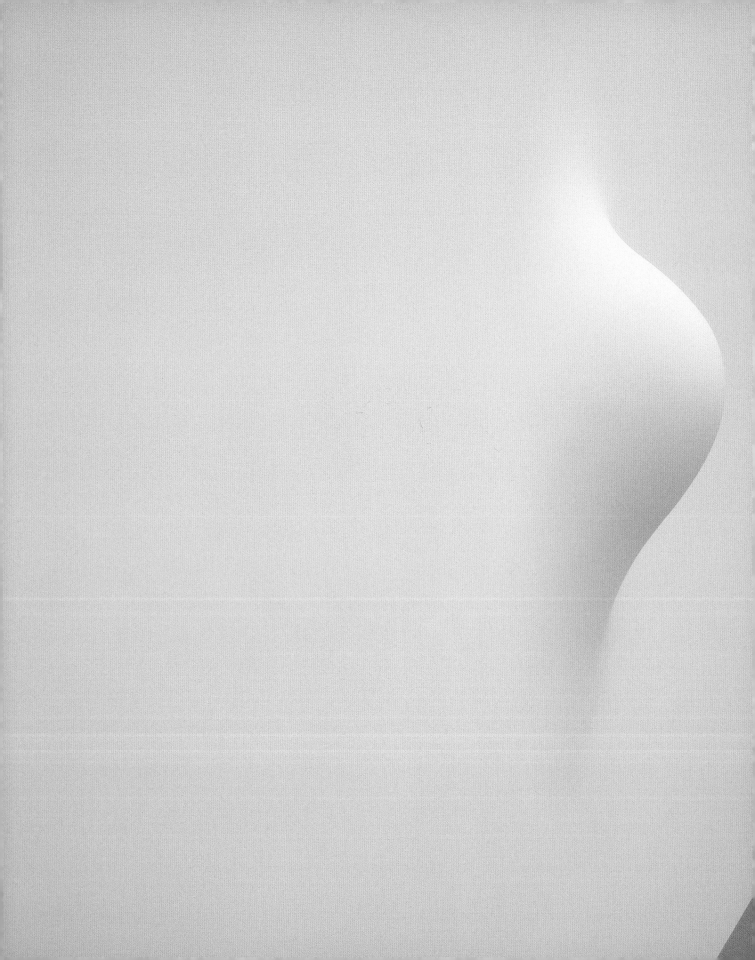

When I am Pregnant 1992

Fibreglass, wood and paint
180.5 × 180.5 × 43
Courtesy of the artist
and Lisson Gallery
(preceding pages)

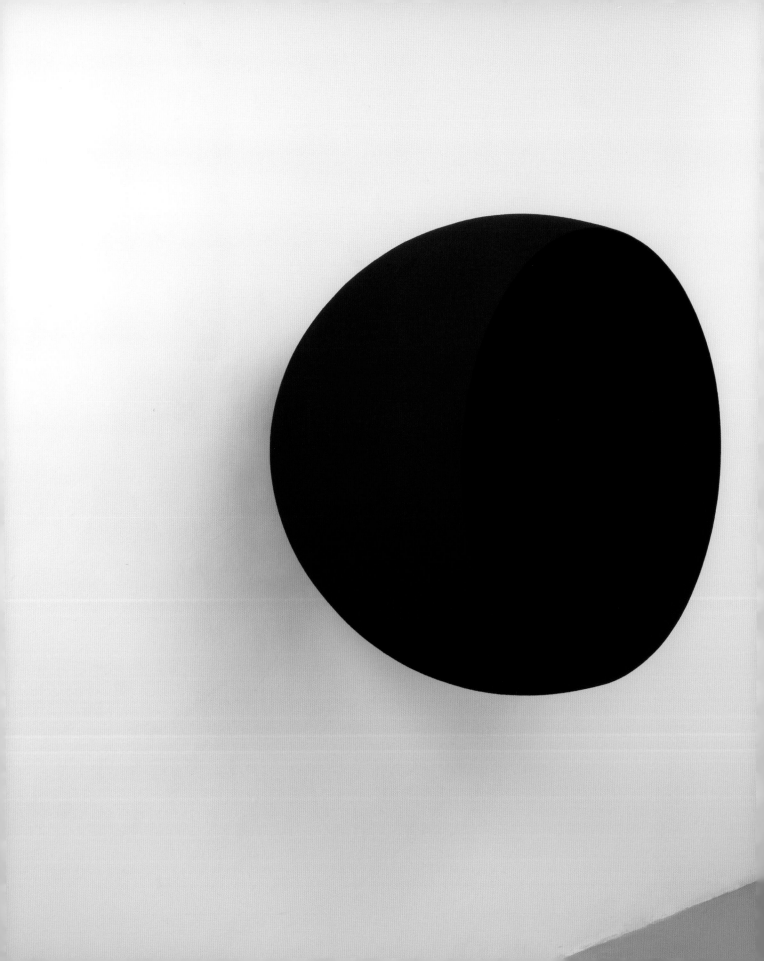

Void 1994

Fibreglass and pigment
110 diameter
British Council Collection

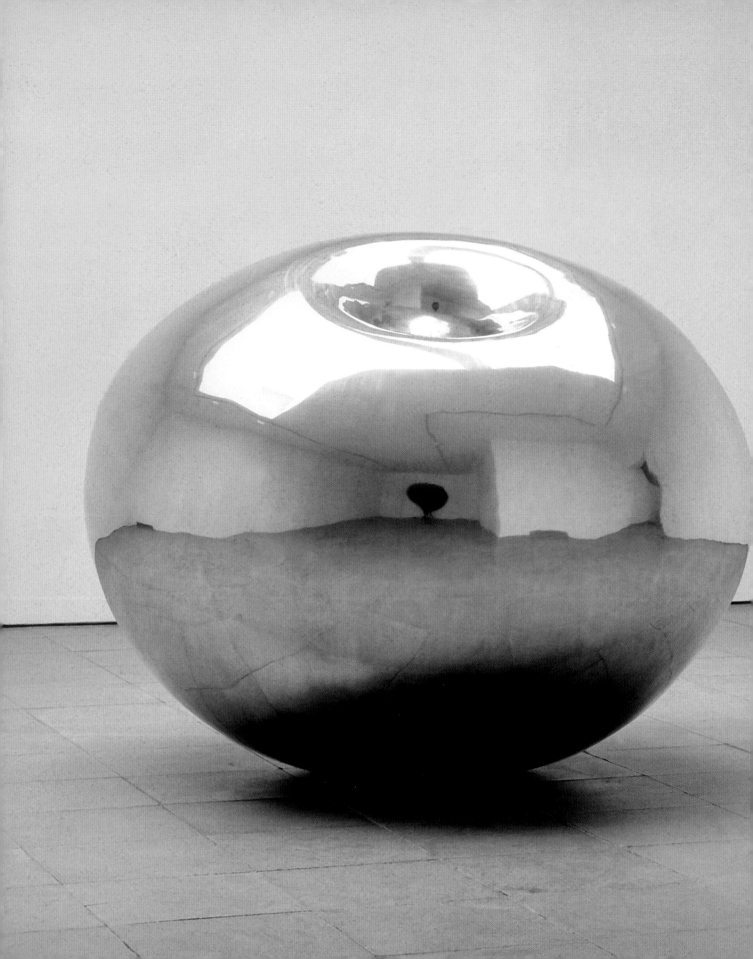

Turning the World Inside Out 1995

Stainless steel
148 × 184 × 188
Bradford Museums and Galleries.
Purchased with funding from the
proceeds of the National Lottery
through the Arts Council of
England, the Art Fund and The
Henry Moore Foundation, 1997
(preceding page)

Untitled 1995

Stainless steel
140 × 92.6 × 100
Arts Council Collection,
Southbank Centre, London.
Acquired with assistance from
The Henry Moore Foundation, 1998

Her Blood 1998

Stainless steel and lacquer
Three parts, each 349 × 349 × 41.6
Tate. Purchased with assistance
from Tate Members, with funds
provided by the Estate of
Father John Munton, the artist,
and Nicholas Logsdail, 2003

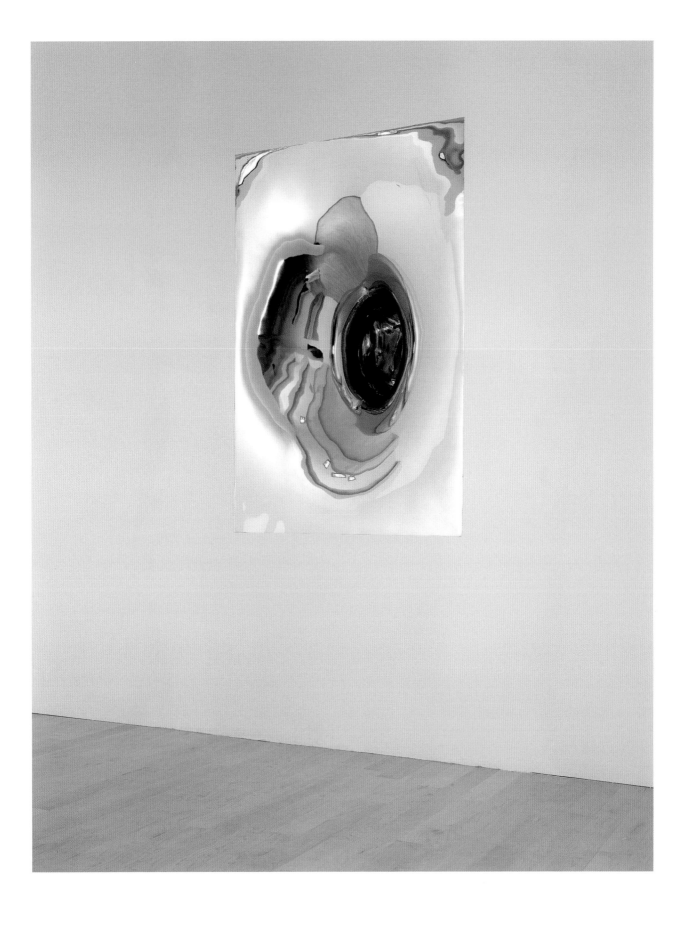

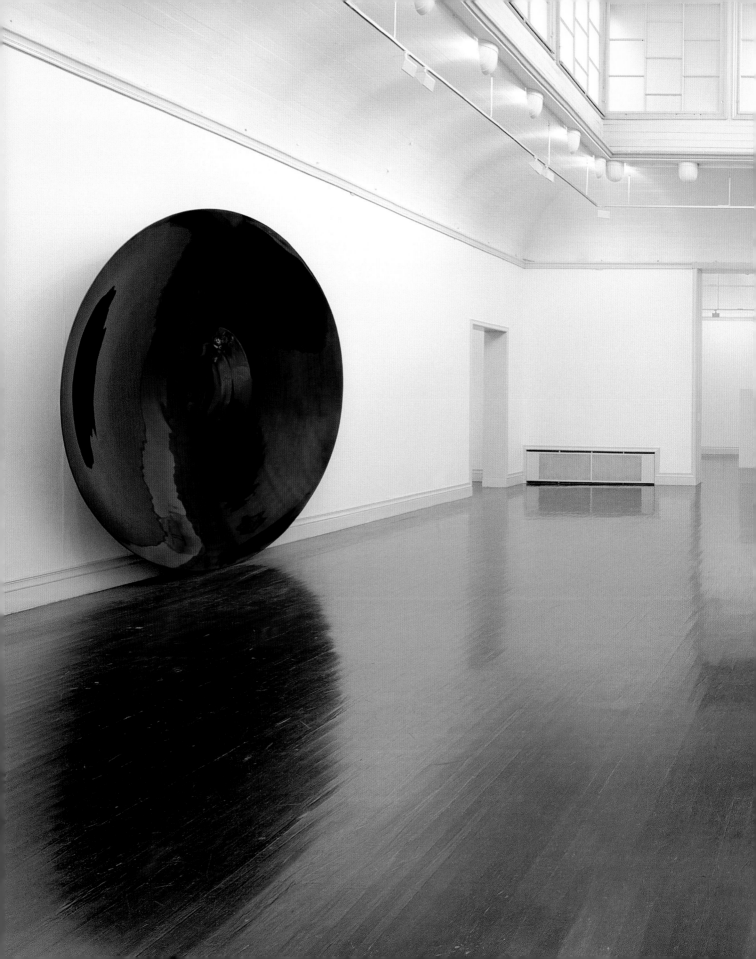

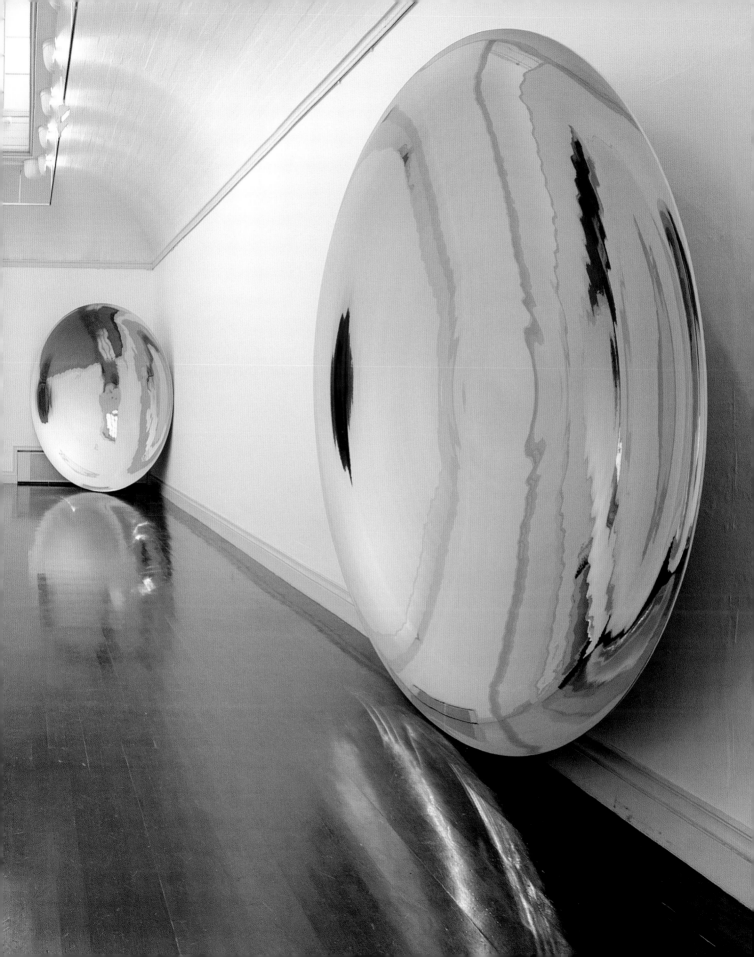

Moon Shadow 2005

Wood, wax and oil based paint
129 × 90 × 49
Courtesy the artist

Negative Box Shadow 2005

Wood, steel, fibreglass and wax
217 × 166 × 142
Courtesy the artist

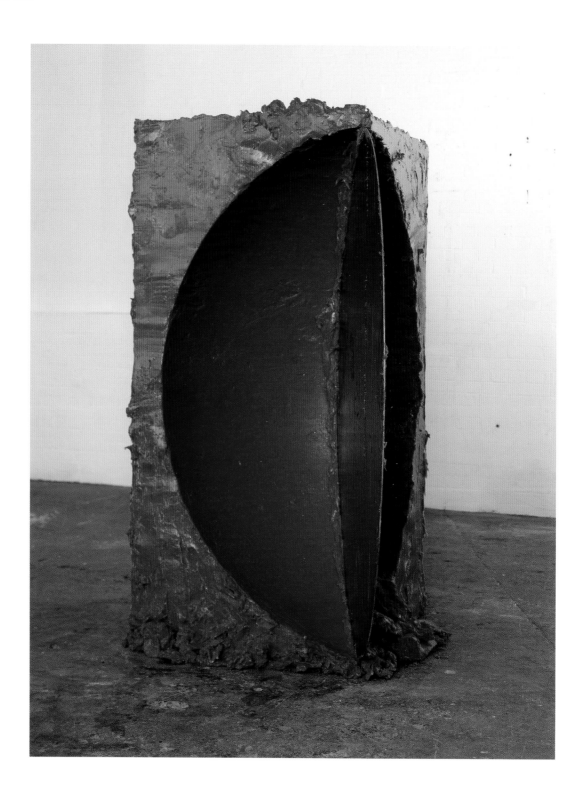

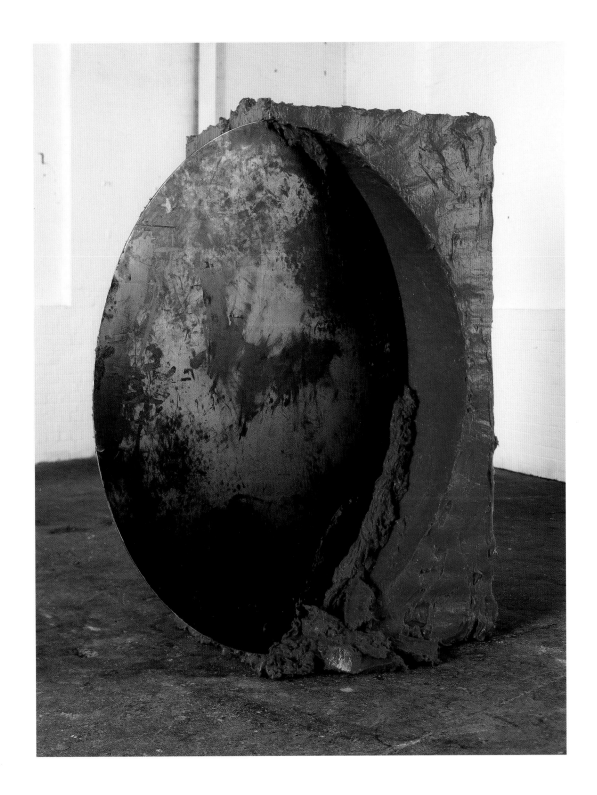

Untitled, 2010

Wax, oil based paint and steel
135.5 × 135.5 × 222.5
Courtesy the artist

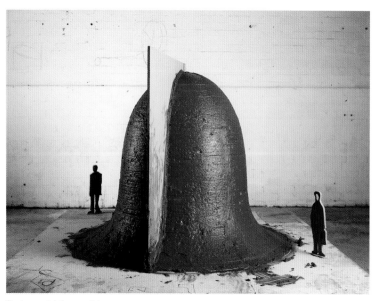

Scale model for revolving
wax work, 2004–2005

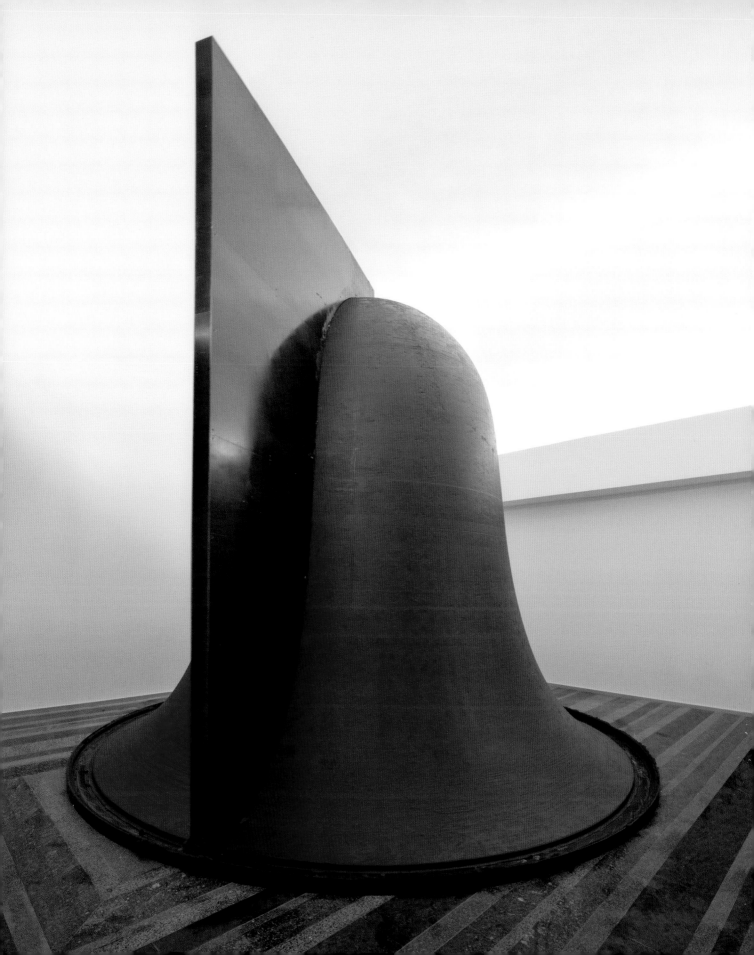

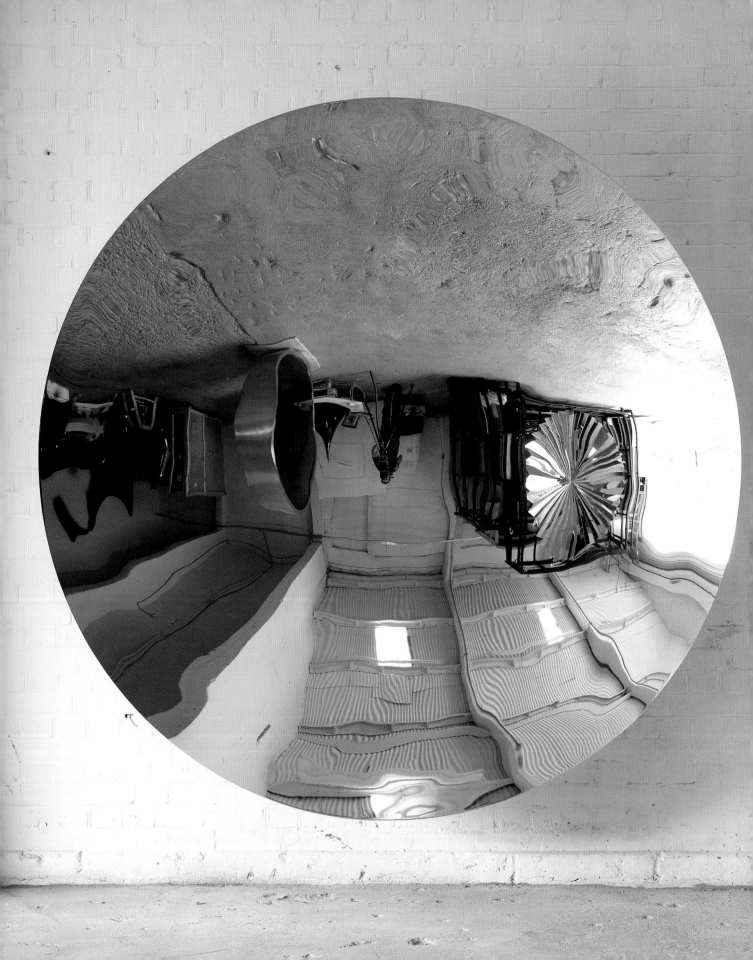

CHRONOLOGY

Untitled, 2008
Artist's studio

1954–73

Anish Kapoor was born in Mumbai, India, in 1954. He recalls a 'marvellous childhood, growing up with a very powerful culture in a context where my parents were both in a sense quite aloof from the culture.'[1]

Kapoor studied at The Cathedral School in Mumbai from 1959 to 1966. In 1966 his father accepted a position as a hydrographer for the Indian Navy. The family relocated to Dehradun and Kapoor's secondary education was undertaken at The Doon School.

Although this academic education provided little in the way of formal art tuition, Kapoor recalls an early immersion in the culture: 'Of course there were museums, we did that. But really the culture and art was all around us.'[2] Kapoor was also conscious of Western art, particularly the early work of Pablo Picasso and its influence on a young Jackson Pollock, and he also admired the work of Mark Rothko.

On completing his secondary education in 1970, Kapoor went out with his brother to live on a kibbutz in Israel for a period of three years. He decided at this time that he wanted to be an engineer: 'I always felt that the thing I enjoyed most was making things with my hands.'[3] He enrolled at an Israeli university, but soon realised that engineering was not for him. Kapoor returned to the kibbutz and resolved that he would become an artist: 'I never thought about it again. It was a very clear decision.'[4]

1973–78

In April 1973, Kapoor arrived in London to study at Hornsey College of Art, first completing a foundation course before going on to undertake an undergraduate degree in Fine Art. He immersed himself in international developments in contemporary art and was drawn particularly to Arte Povera, the work of Joseph Beuys and Fluxus, as well as Minimalists Carl

Andre, Donald Judd and Sol LeWitt. Kapoor was also influenced by the deeply ritualised environments of Paul Thek (1933–1988) and the mystical performances of the UK-based Romanian artist Paul Neagu (1938–2004). 'He opened my eyes to the idea that making art wasn't about making more or less beautiful things and that there was some deeper purpose to it.'[5] Kapoor also undertook substantial reading of Jungian psychoanalysis whilst at Hornsey. He became intrigued by Carl Jung's concept of 'anima' – the presence of unconscious female characteristics within man.

Kapoor started to forge his own identity as an artist, choosing sculpture and installation as his primary media, yet also involving aspects of performance. Centring on the relationship between the body and spirit, male and female, presence and absence, stillness and action, these untitled environments – *Untitled* (1975) being a prime example – were often large in scale and brought

Untitled, 1975
Hornsey College of Art, 1975

together a 'harmony of elements that coexist in the same space and have a common matrix (the body).'[6]

Kapoor's early work was quickly recognised. In 1974, he contributed work to a group show entitled *Landscape into Art* at the Serpentine Gallery in London, and in the following year his sculpture was represented in the *Young Contemporaries* exhibition at the Royal Academy.

Following the completion of his first degree in 1977, Kapoor accepted a place on the postgraduate degree course in the sculpture department at Chelsea School of Art in London.

1979–80
On graduation from Chelsea, Kapoor began to establish himself as a professional artist. He shared a large studio in Wapping with two other artists and accepted a teaching post at Wolverhampton Polytechnic, teaching two days a week until 1981. Yet, despite

having created a workable structure within which to operate, Kapoor left Chelsea with a great sense of unease. 'I was beginning to wonder what kind of a person I was. Was I English? Well, I certainly wasn't English. Was I Indian? I felt like I was but didn't know how to understand that. I didn't have any context for it … In order to be an artist I also felt I had to find something that was truly mine.'[7]

A three-week trip to India – his first in seven years – helped bring to an end this moment of uncertainty: 'All those themes I had been working with – about opposition, about fundamental polarities, which seemed elemental – were equally true and elemental in Indian culture.'[8] He became captivated by the physical presence of pure primary colour.

Returning to London, Kapoor immediately began to make his first sculptures using pigment. Painstakingly constructed directly on the floor, these intensely fragile, geometric and organic forms

emerged from the ground like partially submerged islands. Kapoor gave each work in the series the same title: *1000 Names*, implying a sense of infinite creativity and possibility – a veritable lexicon of forms.

Kapoor's first solo exhibition took place in 1980 in the Paris studio of Patrice Alexandre, an artist, professor and fellow tutor at Wolverhampton Polytechnic. Kapoor worked in Alexandre's studio for three weeks to create an ephemeral installation featuring works from the *1000 Names* series.

1981–86
Kapoor continued to develop the language of *1000 Names* throughout the early 1980s; 1981, however, saw the emergence of a new body of work which seemed to depart from his earlier experiments with ephemeral fields. His work of this period tends to comprise between five and seven forms clustered

together in a non-hierarchical manner on the floor. *White Sand, Red Millet, Many Flowers* (1982) reveals the shift towards increasingly organic and vegetal forms. Indeed, Kapoor explicitly perceived the objects in his sculpture of this period as 'functionaries of a garden.'[9]

1981 was an important year for establishing Kapoor's position within contemporary British sculpture. Early in the year, he presented works from the *1000 Names* series at the Coracle Press. In the summer, his work featured in *Objects & Sculpture*, an important exhibition staged at the Institute of Contemporary Arts, London, and Arnolfini, Bristol. Curated by Lewis Biggs, Iwona Blazwick and Sandy Nairne, the exhibition also featured the work of Richard Deacon, Antony Gormley and Peter Randall-Page among others. In the catalogue, Kapoor stated: 'I have no formal concerns; I don't wish to make sculpture about form – it doesn't really interest me. I wish to make sculpture about belief, or about passion, about experience that is outside of material concern.'[10] Kapoor's work was represented in *British Sculpture in the Twentieth Century: Part Two, Symbol and Imagination, 1951–80* at the Whitechapel Art Gallery, London, in November – a major survey from which Tate purchased *As If to Celebrate, I Discovered a Mountain Blooming with Red Flowers* (1981).

During this period, Kapoor's work received increasing international recognition. The term 'New British Sculpture' was coined for a generation of sculptors, including Kapoor, Richard Deacon and Tony Cragg, who were forging new forms for sculpture using anything from pigment and plywood to discarded plastic. Two important exhibitions of 1982 – *British Sculpture Now* at the Kunstmuseum in Lucerne, and *Aperto 82* at the 40th Venice Biennale – gave 'New British Sculpture' an international platform. In the UK, many of these artists were represented by Nicholas Logsdail's Lisson Gallery. Kapoor and Logsdail began to work together in 1982, and to mark the beginning of this affiliation, one that

1000 Names, 1979–80
Artist's studio

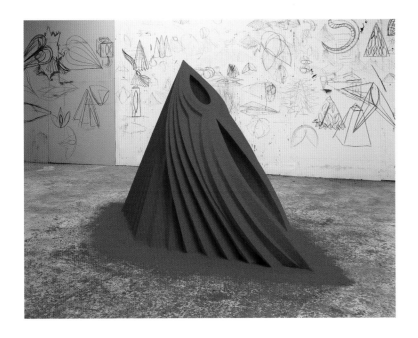

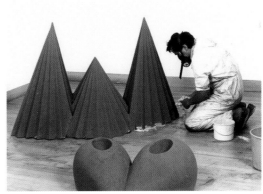

Installing **As if to Celebrate I Discovered a Mountain Blooming with Red Flowers** at the Tate Gallery, 1983

Mother as a Mountain, 1985
Artist's studio

continues to this day, a solo exhibition was held at Lisson Gallery. It was from this exhibition that the Arts Council Collection purchased *White Sand. Red Millet, Many Flowers* (1982).

From March 1982, Kapoor worked as the second artist in residence at the Walker Art Gallery in Liverpool, based at the Bridewell Studios. The residency gave him the opportunity to experiment with earth as a material for sculpture, as evidenced in *Red in the Centre* (1982).

Kapoor's exhibition schedule was particularly intense in 1983, with three solo exhibitions and 12 group shows. As a consequence, he made a deliberate attempt to refine his output in 1984, with just four group shows and his first US solo exhibition, at Barbara Gladstone Gallery in New York. The exhibition was a critical and commercial success, with every work sold before the show opened. Barbara Gladstone continues to represent Kapoor in the US to this day.

1987–92

The mid-1980s were a period of transition for Kapoor as he moved towards a new area of investigation: void space. As he later explained, 'the whole of the tradition of sculpture concentrates on positive form. The negative in sculpture has relied on a symbiotic relationship with the positive. In the last few years I have been working to try and leave behind form and deal with non-form.'[11] The first void works were pigment pieces featuring a hollow space or interior, such as *Mother as a Mountain* (1985). Kapoor then began to experiment with a series of wall-mounted half-spheres made from fibreglass, *At The Hub of Things* (1987) being the first. He recalled: 'when the first void piece went up on the wall it was truly astonishing – it was as if the whole space of the work filled up with a kind of darkness.'[12]

In 1987 Kapoor moved into a new studio in Camberwell where he continues to work today. The extra space enabled

him to extend the language of his sculpture. He began to work in stone, hollowing out a core and painting it a deep Prussian blue in such works as *Adam* (1988–89). The scale and ambition of Kapoor's work in stone reached a high-point with *Void Field* (1989), an installation of 16 blocks of sandstone each weighing two tonnes and featuring a hollowed, darkened core. The piece was first exhibited at Lisson Gallery in the same year. In 1990, Kapoor was chosen to represent Britain at the 44th Venice Biennale. *Void Field* was presented in the British Pavilion alongside other works and, as a result of the show, Kapoor was awarded the 'Premio Duemila' prize. This prize was one of the factors leading to Kapoor's nomination for the Turner Prize, which he won in 1991.

An increasing engagement with architecture emerged in the early 1990s. As Kapoor explained: 'I'd always wanted to make works at an architectural scale – works that you fully walk into and that

aren't objects, but somehow the space and the object are all the same thing. It seemed like a very natural extension.'[13] Two projects of 1992 enabled the artist to realise this aim. The first, *Building for a Void*, was presented at *Expo '92* in Seville. This 15-metre tall cylindrical structure was the result of the first collaboration between the artist and the building designer David Connor. *Descent into Limbo*, created for *Documenta 9* in Kassel, comprised a six-metre cubed concrete structure housing a dark void measuring three metres in diameter. Even Kapoor's gallery-based work of this period revealed an increased consideration of the spaces in which his works were presented. *When I am Pregnant* (1992), for example, morphs seamlessly with its architecture as if it was always somehow present.

1993–98

From 1993, Kapoor's interest in the void found new expression as he began to explore vortex forms, creating works that appeared to suck in the surrounding space. Kapoor also became drawn to the effects of reflective surfaces, turning first to highly polished Kilkenny limestone in 1994, and then, in 1995, to mirrored surfaces. Through the marriage of mirrors and vortices, Kapoor developed a new vocabulary of visual and spatial disorientation, as exemplified in *Turning the World Inside Out* (1995), a polished stainless-steel work pierced by a vortex, which was first exhibited alongside a range of mirrored works at the Fondazione Prada in 1995. 'It's what a mirrored object does to space that I think is interesting – it turns the world upside down, it spatially confuses, it makes objects unreadable. It seems to suggest

that the sublime isn't in the far distance but that there is a modern sublime that might be found in the mirrored object.'[14] Alongside these developments, Kapoor instigated a new body of work called *White Dark*. These are works of subtle beauty, activated by the slightest variation in the controlled surrounding lighting.

In 1995, Kapoor married Susanne Spicale. Their daughter, Alba, was born later in the year, and their son, Ishan, in 1996.

Kapoor's experimentation continued as the decade progressed, with resin, gold leaf and alabaster added to his growing vocabulary. In 1997, his reputation within academic circles was acknowledged when he was awarded Honorary Doctorates from the London Institute and Leeds University. Seven solo shows were staged in 1998, including a major exhibition at the Hayward Gallery featuring over 20 works. The show was intended less as a

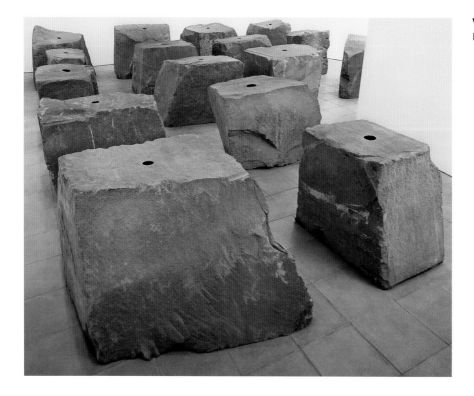

Void Field, 1989
Lisson Gallery, 1993

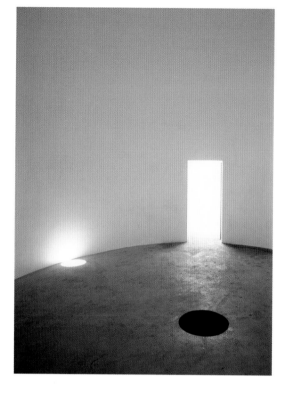

Building for a Void, 1992
Project for Expo'92, Seville

retrospective and more as an exploration of recent developments from the *White Dark* series to the mirrored works. 'The exhibition unfolds as a series of propositions, of encounters between works, as a sequence of discrete experiences. The cumulative effect, however, highlights the essential continuity of Kapoor's aims. As he remarked of his work in 1996: "Some interests have deepened, but really the central issues have stayed the same."'15

1999–2005

The turn of the century witnessed the confirmation of Kapoor's status as a leading figure in British art. In 1999 he was awarded an Honorary Doctorate from the University of Wolverhampton and he was also elected a member of the Royal Academy. An Honorary Fellowship

from the Royal Institute of British Architects followed in 2001 and, in 2003, Kapoor was the recipient of the Dayawati Modi Award and made Commander of the British Empire for his contribution to the arts. The Louise T. Blouin Foundation Award followed in 2005.

This phase of Kapoor's career is also notable for the ambition of his site-specific work (see pp. 90–95). The first significant project to be realised in the UK was *Taratantara*, a 50-metre long PVC form that stretched across the empty void of Baltic Flour Mill in the summer of 1999 before the building was converted into BALTIC Centre for Contemporary Art (p. 90). *Taratantara* was presented again in the Piazza Plebiscito in Naples in 2001. Following two unrealised proposals for London-based projects – one for Southbank Centre's Jubilee Gardens and

the second for the Salvation Army building, Kapoor undertook two further UK projects in quick succession: the presentation of *Sky Mirror* outside Nottingham Playhouse in 2001 and *Marsyas* (2002) – a vast PVC structure spanning Tate Modern's 150-metre long Turbine Hall (p. 68). The work was created with the technical assistance of the engineer Cecil Balmond. Further international projects followed: in 2003 Kapoor designed an underground station for Naples, and in the same year he won the commission to design a memorial for the British victims of the 11 September 2001 attacks on the World Trade Center in New York. In 2004 *Cloud Gate* was unveiled in Millennium Park, Chicago, marking Kapoor's first permanent, site-specific installation in the US.

Alongside these site-specific projects, significant new directions were starting

to emerge within Kapoor's gallery-based practice. In 2003, a major exhibition of his work was staged at the Kunsthaus Bregenz in Austria. The show took its title from a new work – *My Red Homeland* – on display for the first time. The installation comprised almost 25 tonnes of dark red wax swept in circular motion, one revolution per hour, by a gigantic steel pestle. Fascinated by the concept of auto-generation, and by visceral materiality, Kapoor started to experiment with the properties of red wax from 2004.

2006 to the present

Kapoor's recent practice has continued to embrace an increasingly ambitious range of projects and commissions both in the UK and overseas. In 2006, with the assistance of the Public Art Fund, *Sky Mirror* was sited outside the Rockefeller Center in New York. The piece, weighing 23 tonnes and spanning a diameter of 10.6 metres, inverted the vertiginous skyscraper, bringing the sky down to the ground.

Kapoor's first solo show in Latin America took place at the Centro Cultural Banco do Brasil in Rio de Janeiro in 2006 and later toured to São Paolo, featuring

a range of work including *Ascension* – a column of smoke arising out of the ground in a tornado formation. In São Paolo, *Ascension* was presented in a purpose-built structure beneath a bridge known as a popular meeting place for disaffected young people. A community project funded by Kapoor and a group of Brazilian collectors followed.

Svayambh, at the Musée des Beaux-Arts de Nantes in 2007, featured just one work of the same title. Sanskrit for 'auto-generated' or 'self-made', *Svayambh* comprised a slab of dark red wax set on rails which moved slowly through the doorways of the gallery to leave an

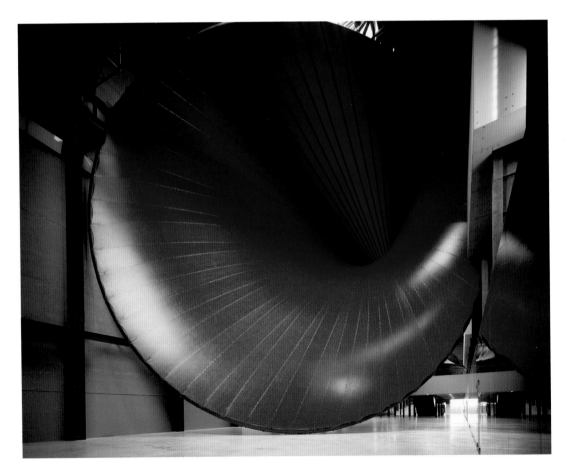

Marsyas
Tate Modern, 2002

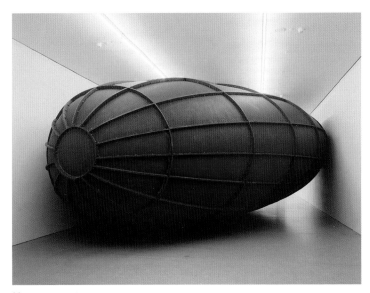

Memory, 2008
Deutsche Guggenheim, 2008–9

impression of and on the surrounding architecture. The piece was included in Kapoor's mid-career survey at the Haus der Kunst in Munich in the same year and in a retrospective at the Royal Academy in London in 2009. The Royal Academy exhibition featured work including *Shooting into the Corner* – a cannon firing barrels of wax with heart-stopping force into the corner of the gallery. The show attracted 275,000 visitors in three months, making it the most popular exhibition by a living artist ever held in London.

In 2008 Kapoor accepted the fourteenth Deutsche Guggenheim commission to create a site-specific work entitled *Memory* for its gallery in Berlin, made from Cor-Ten steel. The work later toured to the Guggenheim, New York.

Despite Kapoor's international success, an exhibition of his work had, until recently, never been staged in his native India. *Anish Kapoor: Delhi/Mumbai*, organised by the British Council, took place simultaneously at the National Gallery of Modern Art, Delhi and the Mehboob Film Studios in Mumbai.

In 2010, *Turning the World Upside Down*, a presentation of stainless steel works in London's Kensington Gardens, marked his ongoing engagement with a range of site-specific projects. These include the *Tees Valley Giants* series of megalithic structures, in progress in North East England (see *Temenos*, pp. 8–9), and the much anticipated *Orbit*, a 115-metre-tall spiralling centrepiece for the 2012 Olympic Games site in Stratford, East London. Despite Kapoor's continuing presence within British art and culture, a survey of his work has never taken place in the UK beyond the capital. The Arts Council Collection's exhibition *Flashback: Anish Kapoor* addresses this gap, touring to Manchester Art Gallery, The Sculpture Court at Edinburgh College of Art, Nottingham Castle Museum and Art Gallery and Longside Gallery, Yorkshire Sculpture Park.

COMPILED BY NATALIE RUDD

1 'Anish Kapoor interviewed by Douglas Maxwell', *Art Monthly*, issue 136, May 1990, as reproduced in *Talking Art: Interviews with Artists since 1976*, eds. Patricia Bickers and Andrew Wilson, Art Monthly and Ridinghouse, 2007, pp. 330–39.
2 Ibid.
3 Ibid.
4 Ibid.
5 Ibid.
6 Germano Celant, *Anish Kapoor*, Thames and Hudson, London, 1996, p. XV.
7 Ibid.
8 Ibid.
9 Ibid.
10 *Objects & Sculpture*, Arnolfini Gallery, Bristol and Institute of Contemporary Arts, London, 1981, p. 20.
11 'Homi Bhabha and Anish Kapoor A Conversation', *Anish Kapoor*, Tel Aviv Museum of Art, 1993, p. 59.
12 From a conversation with Matt Price, 'Chronology', *Anish Kapoor*, Phaidon, London, 2009, p. 497.
13 Ibid., p. 499.
14 Ibid.
15 Martin Caiger-Smith, *Anish Kapoor*, exhibition guide, Hayward Gallery, 1998.

Overleaf: **Cloud Gate**, 2004
Millennium Park, Chicago

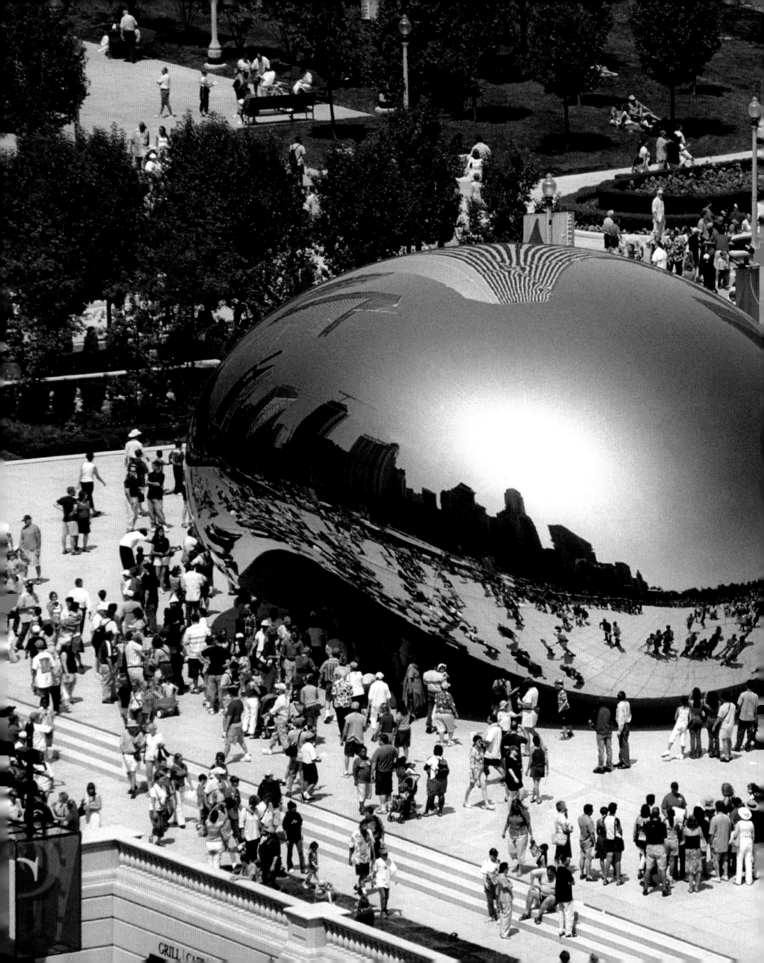

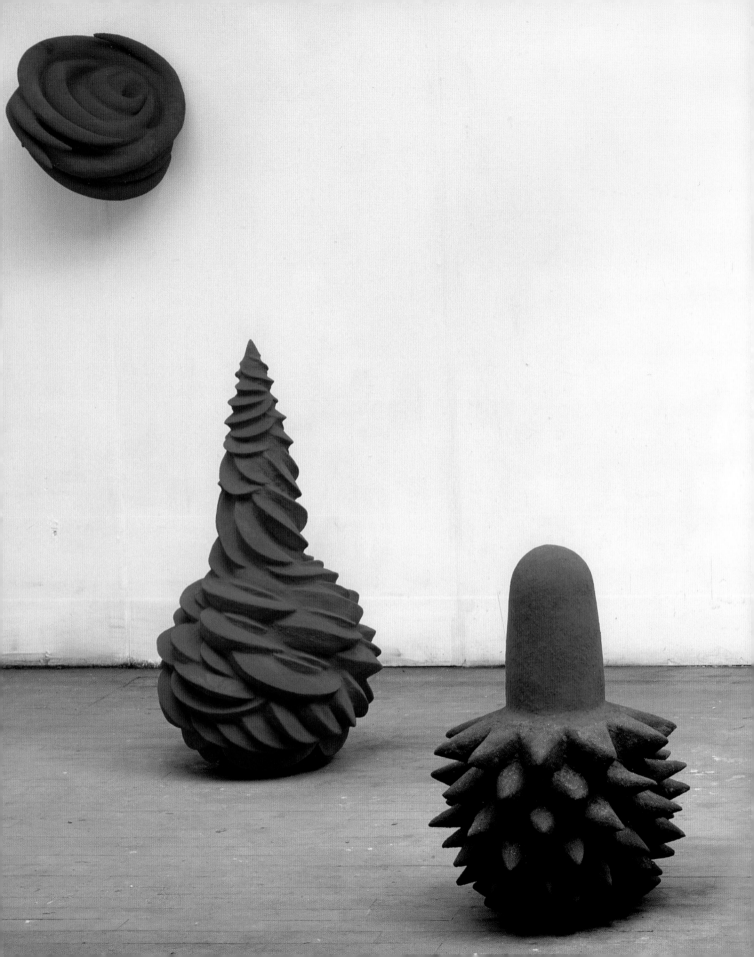

Over the next ten pages are listed all works by Anish Kapoor in British public collections. They form a virtual extension of the exhibition across the country, and we hope that this will prove a valuable resource for the future, as well as encouraging people to seek out the works themselves. At the same time this exercise serves to highlight the richness of our regional collections. Great collections are built upon the passions of individuals, both curators and patrons. Furthermore the list of works that follows illuminates the enlightened and astute work of donors and funding bodies such as the Art Fund, The Henry Moore Foundation and the Contemporary Art Society in supporting the continued collecting of contemporary art in Britain.

We have made every effort to ensure that this list is complete, but we invite collections to contact us with details of any further works. Dimensions are given in centimetres, height × width × depth.

Untitled, 1983
Artist's studio

Bradford Museums and Galleries

↓ *Turning the World Inside Out*, 1995, stainless steel, 148 × 184 × 188; Bradford Museums and Galleries. Purchased with funding from the proceeds of the National Lottery through the Arts Council of England, the Art Fund and The Henry Moore Foundation, 1997

Scottish National Gallery of Modern Art, Edinburgh

→ *Untitled,* 1983, fibreglass and pigment, 130 × 92 × 98; presented by The Contemporary Art Society 1987; purchased from Lisson Gallery with assistance from the Henry Moore Foundation 1984

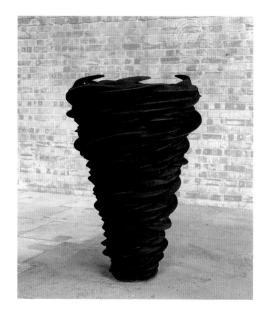

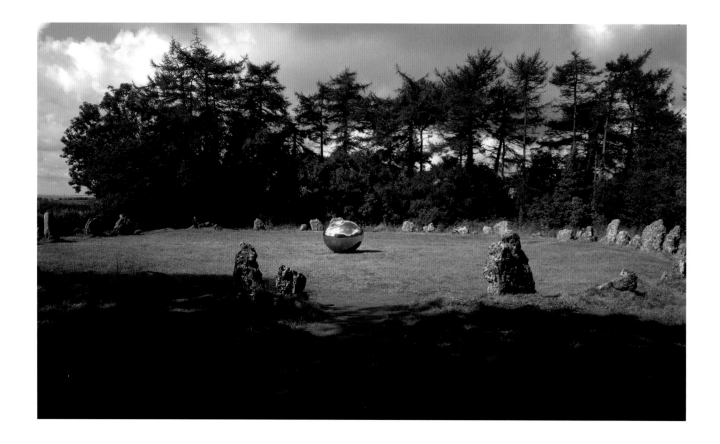

Leeds Museums and Galleries

Untitled, 1989, oil and emulsion on paper,
75 × 54.4; presented by the Contemporary
Art Society 1992

→ *Void Stone*, 1990, limestone and pigment,
125 × 129 × 94; presented by the
Contemporary Art Society 1991

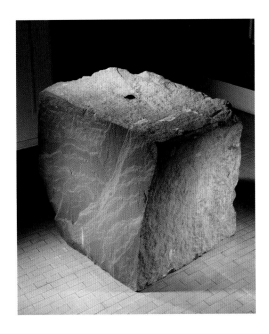

**National Museums Liverpool,
Walker Art Gallery**

Red in the Centre, 1982, mixed media
and pigment, dimensions variable;
purchased from the artist 1982

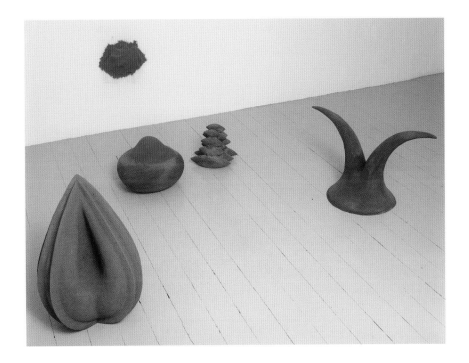

**Arts Council Collection,
Southbank Centre, London**

→ *White Sand, Red Millet, Many Flowers,*
1982, mixed media and pigment,
101 × 241.5 × 217.4; purchased 1982

↓ *Untitled*, 1995, stainless steel,
140 × 92.6 × 100; acquired with assistance
from The Henry Moore Foundation, 1998

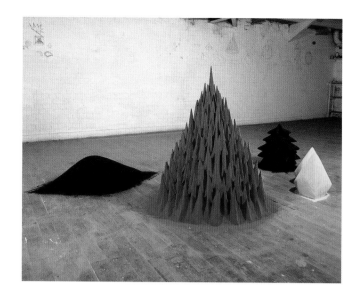

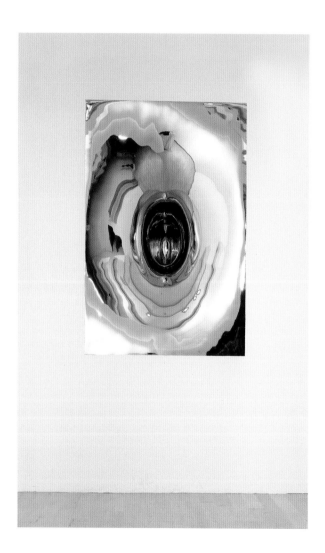

British Council Collection, London

↓ *The Chant of Blue*, 1983, mixed media and pigment, three parts 61 × 61 × 61; one part 76 × 76 × 76; purchased from Lisson Gallery 1983

→ *Void*, 1994, fibreglass and pigment, 110 diameter; gifted by the artist 1996

15 Etchings, 1995, prints on paper, published by Charles Booth-Clibborn under his imprint The Paragon Press, 29 × 37.5 (plate), 51 × 58.2 (sheet); purchased from Paragon Press 1996

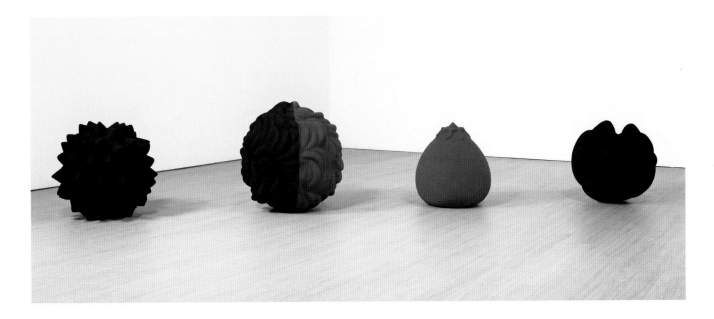

Wounds and Absent Objects, 1998, portfolio of nine pigment transfer prints, published in 1998 by Charles Booth-Clibborn under his imprint The Paragon Press in an edition of 12, proofed by Adam Lowe, 44.6 × 53; purchased from Paragon Press 1998

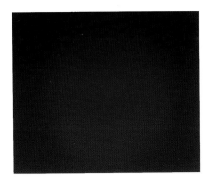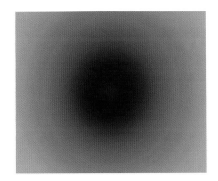

British Museum, London

→ *15 Etchings,* 1995, prints on paper, published by Charles Booth-Clibborn under his imprint The Paragon Press, 29 × 37.5 (plate), 55.6 × 53 (sheet); purchased from The Paragon Press, funded by 20th Century Graphics Fund 1996

15 Etchings, 1995, prints on paper, published by Charles Booth-Clibborn under his imprint The Paragon Press, 29 × 37.5 (plate), 55.6 × 53 (sheet); purchased by Alexander Walker from The Paragon Press 1995, Bequeathed by Alexander Walker 2004

Blue Square, 1996, pigment on paper, 38.5 × 28.7; purchased from Austin Desmond Fine Art, funded by Rootstein Hopkins Foundation 2008

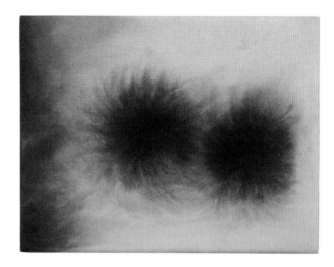

Government Art Collection, London

↓ *Untitled*, 1989, coloured aquatint,
77.7 × 69; purchased from the Public Art
Development Trust 2005

↘ *Untitled*, 1989, coloured aquatint,
77.3 × 69.3; purchased from the Public Art
Development Trust 2005

Turning the World Inside Out, 1995,
stainless steel, 148 × 184 × 188; artist's proof
no.1; purchased from Lisson Gallery 1998

Untitled, 2002, coloured aquatint,
72.7 × 86.4; presented by Artworks
(Clore Duffield Foundation) 2002

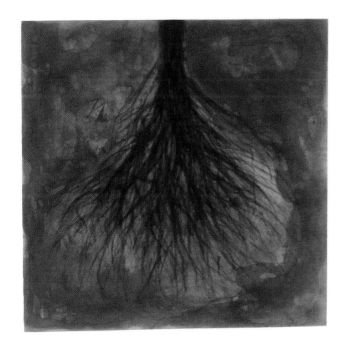
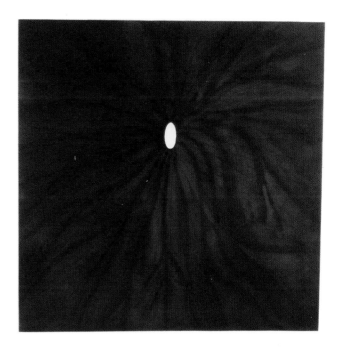

Tate, London

→ *As if to Celebrate, I Discovered a Mountain Blooming with Red Flowers,* 1981, mixed media and pigment, 107 × 305 × 305; purchased 1983

↘ *Three,* 1982, mixed media and pigment, 78.5 × 350 × 79; purchased 1989

↓ *Untitled,* 1983, mixed media and pigment, 114 × 58 × 58; 79 × 57.5 × 57; 62 × 59 × 59; 54 × 46 × 46; lent by the American Fund for the Tate Gallery, courtesy of the Carol and Arthur Goldberg Collection honour of the New Museum of Contemporary Art, New York City 2000

Adam, 1988–89, sandstone and pigment, 239 × 120.5 × 10.4; presented by the American Fund for the Tate Gallery, courtesy of Edwin C. Cohen (for A., A., A. and J.) 2000

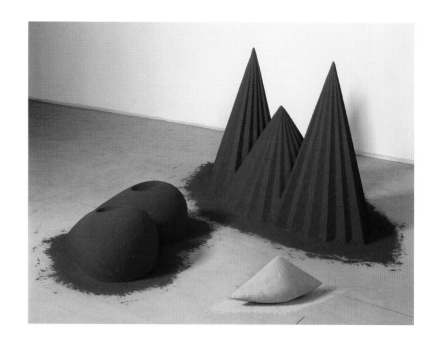

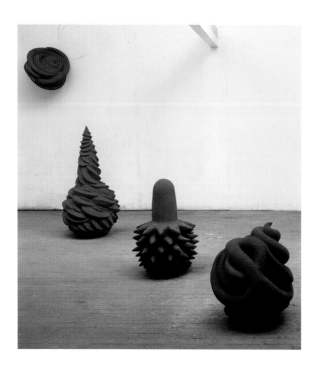

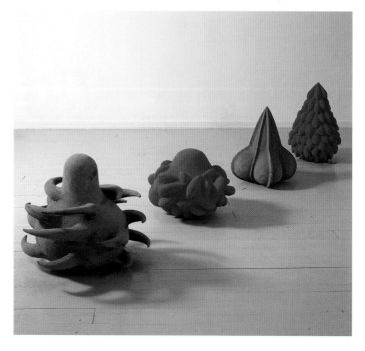

→ *A Wing at the Heart of Things*, 1990,
slate and pigment, 28 × 353 × 270;
25 × 295 × 320; purchased 1990

Her Blood, 1998, stainless steel and lacquer,
349 × 349 × 41.6; purchased with assistance
from Tate Members, with funds provided
by the Estate of Father John Munton,
the artist, and Nicholas Logsdail 2003

↓ *Ishi's Light*, 2003, fibreglass and lacquer,
315 × 250 × 224; presented by Tate
International Council 2005

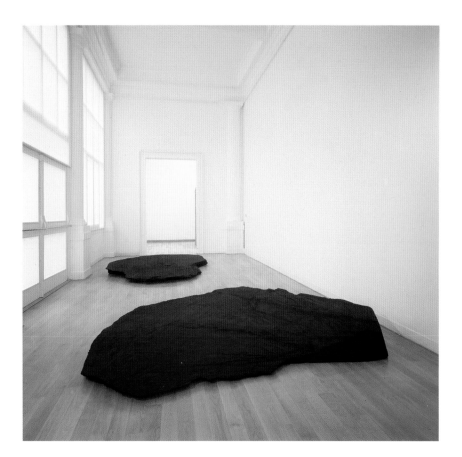

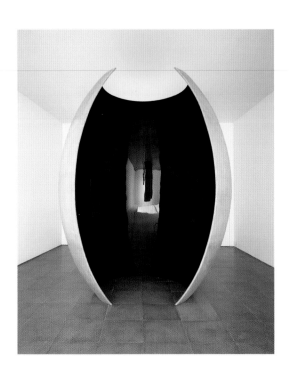

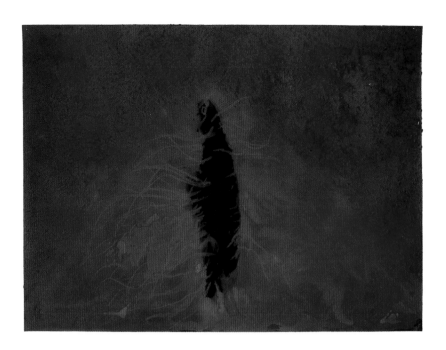

WORKS ON PAPER

Untitled, 1986, ink wash on paper, 31 × 44; presented by the Weltkunst Foundation 1988

Untitled, 1986, gouache, ink, pencil, pigment and emulsion on paper, 74.7 × 55.9; purchased 1991

Untitled, 1987, gouache on paper, 38.5 × 30.2; presented by the Weltkunst Foundation 1988

Untitled, 1987–88, gouache, papier maché and clay on paper, 54 × 76; presented by the Weltkunst Foundation 1988

Untitled, 1987–88, gouache on paper, 42 × 35; presented by the Weltkunst Foundation 1988

Untitled, 1988, gouache on paper, 56 × 56; presented by the Weltkunst Foundation 1988

Untitled 2, 1988, intaglio print on paper, 45 × 35; purchased 1989

Untitled 3, 1988, intaglio print on paper, 45.3 × 35; purchased 1989

Untitled 5, 1988, intaglio print on paper, 44.8 × 35; purchased 1989

Untitled I, 1988, aquatint on paper, 113.3 × 89.8; purchased 1989

Untitled II, 1988, aquatint and drypoint on paper, 113.3 × 89.8; purchased 1989

Untitled III, 1988, aquatint on paper, 89.8 × 113.3; purchased 1989

Untitled, 1989, intaglio print on paper, 51.3 × 51.5; presented by the King Edward's Hospital Fund 1989

Untitled, 1989, intaglio print on paper image, 51.3 × 51.5; presented by the King Edward's Hospital Fund 1989

Untitled, 1989, gouache, pigment and damar on paper, 70 × 49.8; presented by the artist 1991

Untitled, 1989, acrylic, gouache, pencil and oil stain on paper, 54.5 × 58.5; presented by the artist 1991

Untitled, 1989, varnish and pencil on paper, 50 × 48; purchased 1991

Untitled, 1989, acrylic, oil stain and pencil on paper, 58.5 × 55.8; purchased 1991

Untitled, 1989, earth and gouache on paper, 76 × 56; purchased 1991

↑ *Untitled*, 1990, earth, PVA and gouache on paper, 56.2 × 76.1; presented by the artist 1991

Wounds and Absent Objects, 1998, portfolio of nine pigment transfer prints, published in 1998 by Charles Booth-Clibborn under his imprint The Paragon Press in an edition of 12, proofed by Adam Lowe, 44.6 × 53; purchased 1998

Blackness from her Womb, 2000, portfolio of 13 etchings, 43 × 38; purchased 2002

Victoria & Albert Museum, London

Untitled, 1988, aquatint, printed in red and black ink on paper, Crown Point Press, California; 113.2 × 89.6 (plate), 134.8 × 106.9 (sheet); purchased 1992

Album page in publication to mark V&A's 150th anniversary of its opening at the South Kensington site. Photographs of Anish Kapoor's sculptures and the Ardabil carpet, with printed lettering at top left, 2007; 29.7 × 42; gifted by the artist 2007

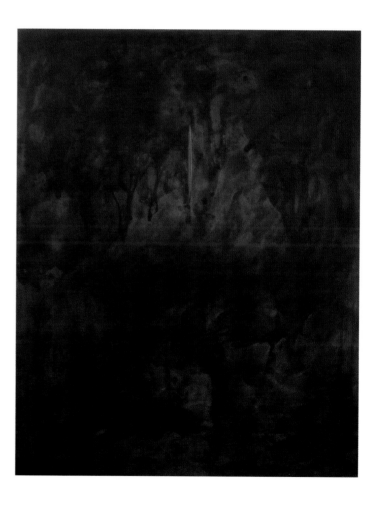

SOLO EXHIBITIONS

COLLABORATIONS,
COMMISSIONS
AND PROJECTS

Tall Tree and the Eye, 2009
Royal Academy of Arts, 2009

SOLO
EXHIBITIONS

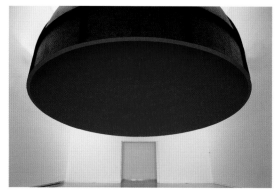

At the Edge of the World, 1998
Hayward Gallery, London, 1998

1980 Patrice Alexandre, Paris

1981 Coracle Press, London

1982 Lisson Gallery, London
Walker Art Gallery, Liverpool

1983 Galerie 't Venster, Rotterdam
Walker Art Gallery, Liverpool;
travelled to Le Nouveau Musée,
Villeurbanne, Lyon
Lisson Gallery, London

1984 Barbara Gladstone Gallery, New York

1985 Lisson Gallery, London
Kunsthalle, Basel; travelled to
Stedelijk Van Abbemuseum,
Eindhoven

1986 Kunstnernes Hus, Oslo
Barbara Gladstone Gallery, New York
*Anish Kapoor: Recent Sculpture
and Drawings*, University Gallery
at University of Massachusetts,
Amherst

1987 *Anish Kapoor: Works on Paper
1975–1987*, Ray Hughes Gallery,
Sydney; travelled to Museum of
Modern Art, Brisbane, Australia

1988 Lisson Gallery, London

1989 Barbara Gladstone Gallery,
New York
Kohji Ogura Gallery, Nagoya
Void Field, Lisson Gallery, London

1990 *Anish Kapoor, XLIV Biennale di
Venezia*, British Pavilion, Venice
(organised by the British Council)
Drawings, Barbara Gladstone
Gallery, New York
Anish Kapoor Drawings,
Tate Gallery, London
Le Magasin, Centre National
d'Art Contemporain, Grenoble
(organised in cooperation with
the British Council)

1991 Palacio de Velázquez, Centro
de Arte Reina Sofía, Madrid
(organised in cooperation with
the British Council)
Kunstverein Hannover
(organised in cooperation with
the British Council)
The 6th Japan Ushimado
International Art Festival
Anish Kapoor & Ban Chiang,
Feuerle Gallery, Cologne

1992 Galeria Soledad Lorenzo, Madrid
Stuart Regen Gallery, Los Angeles
San Diego Museum of Contemporary
Art, La Jolla; travelled to
Des Moines Art Center, Iowa:
The National Gallery of Canada,
Ottawa; The Power Plant, Toronto

1993 Tel Aviv Museum of Art
Lisson Gallery, London
Barbara Gladstone Gallery, New York

1994 Mala Galerija, Moderna Galerija
Ljubljana and Museum of
Modern Art, Slovenia
Echo, Kohji Ogura Gallery, Nagoya
(organised in cooperation with
the Lisson Gallery)

1995 DePont Foundation, Tillburg;
travelled to Nishimura Gallery, Tokyo
Prada Milanoarte, Milan
Lisson Gallery, London

1996 *Anish Kapoor: Sculptures*,
Aboa Vetus & Ars Nova, Turku
Anish Kapoor: Two Sculptures,
Kettle's Yard, Cambridge
Galleria Massimo Minini, Brescia
Gourd Project 1993–95,
Freddie Fong Contemporary Art,
San Francisco

1997 Kunst-Station Sankt Peter, Cologne

1998 Lisson Gallery, London
Galleria Massimo Minini, Brescia
Barbara Gladstone Gallery,
New York
CAPC Museé d'Art Contemporain,
Bordeaux
Her Blood, La Chapelle de la
Salpetriere, Paris
Dobre Espacio, Centro Galego de
Arte Contemporanea, Santiago
de Compostela
Hayward Gallery, London

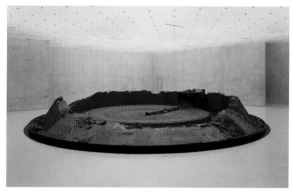

My Red Homeland, 2003
Kunsthaus Bregenz, 2003

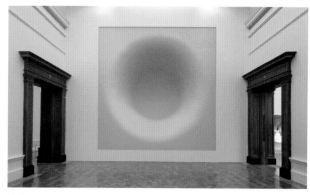

Yellow, 1999
Royal Academy of Arts, 2009

1999 Scai The Bathhouse, Tokyo
Andre Viana, Porto
Taratantara, BALTIC Centre for
Contemporary Art, Gateshead and
Piazza del Plebiscito, Naples

2000 *Blood*, Lisson Gallery, London
Regen Projects, Los Angeles
The Edge of the World, permanent
installation at Axel Vervoordt
Kanal, Wijnegem
Blood Solid, fig-1, London

2001 Barbara Gladstone Gallery,
New York
Taidehalli, Helsinki

2002 *The Unilever Series: Anish Kapoor,
Marsyas*, Turbine Hall, Tate Modern,
London

2003 *My Red Homeland*, Kunsthaus
Bregenz
Museo Archeologico Nazionale,
Naples
Blood Solid, Art of This Century,
New York
Painting, Lisson Gallery, London
Kukje Gallery, Seoul
Galleria Continua, San Gimignano

2004 *Whiteout*, Barbara Gladstone
Gallery, New York
Galleria Massimo Minini, Brescia
Melancholia, MAC Grand-Hornu

2005 *Anish Kapoor, Japanese Mirrors*,
Scai The Bathhouse, Tokyo

2006 Regen Projects, Los Angeles
Lisson Gallery, London
Anish Kapoor: Ascension, Centro
Cultural Banco Do Brasil, Rio de
Janeiro; travelled to Brasilia and
São Paulo
My Red Homeland, Centro de Arte
Contemporaneo de Malaga
Anish Kapoor: Sky Mirror,
Rockefeller Center, New York

2007 *Anish Kapoor: Drawings on Paper*,
Barbara Gladstone Gallery, New
York
Anish Kapoor: Svayambh, Musee
des Beaux-Arts, Nantes
Anish Kapoor: Svayambh, Haus der
Kunst, Munich
Ascension, Galleria Continua, Beijing

2008 *Anish Kapoor: Past, Present, Future*,
Institute of Contemporary Art, Boston
Barbara Gladstone Gallery, New York
Kukje Gallery, Seoul
*Place/No Place: Anish Kapoor in
Architecture*, Royal Institute of
British Architects, London
Anish Kapoor: Islamic Mirror, Sarq
al-Andalus Hall, Museum of the
Monasterio de Santa Clara, Murcia
Anish Kapoor: Memory, Deutsche
Guggenheim, Berlin

2009 *Anish Kapoor: Shooting into the
Corner*, MAK Museum, Vienna
Anish Kapoor: Shadows & Etchings,
La Caja Negra, Madrid
Drawings, Regen Projects,
Los Angeles
Anish Kapoor: New Works,
Lisson Gallery, London
Anish Kapoor, Royal Academy,
London
Anish Kapoor: Memory,
Guggenheim, New York

2010 Museo Guggenheim de Arte
Moderno y Contemporáneo, Bilbao
Middlesbrough Institute of
Modern Art
Turning the World Upside Down,
Kensington Gardens, London
Anish Kapoor: Delhi Mumbai,
National Gallery of Modern Art,
New Delhi and Mehboob
Film Studios, Mumbai

2011 *Anish Kapoor: Flashback*,
Manchester Art Gallery, The
Sculpture Court, Edinburgh College
of Art and Nottingham Castle
Museum and Art Gallery

2012 *Anish Kapoor: Flashback*,
Longside Gallery, Yorkshire
Sculpture Park

Overleaf: Installation view:
Hayward Gallery, 1998.

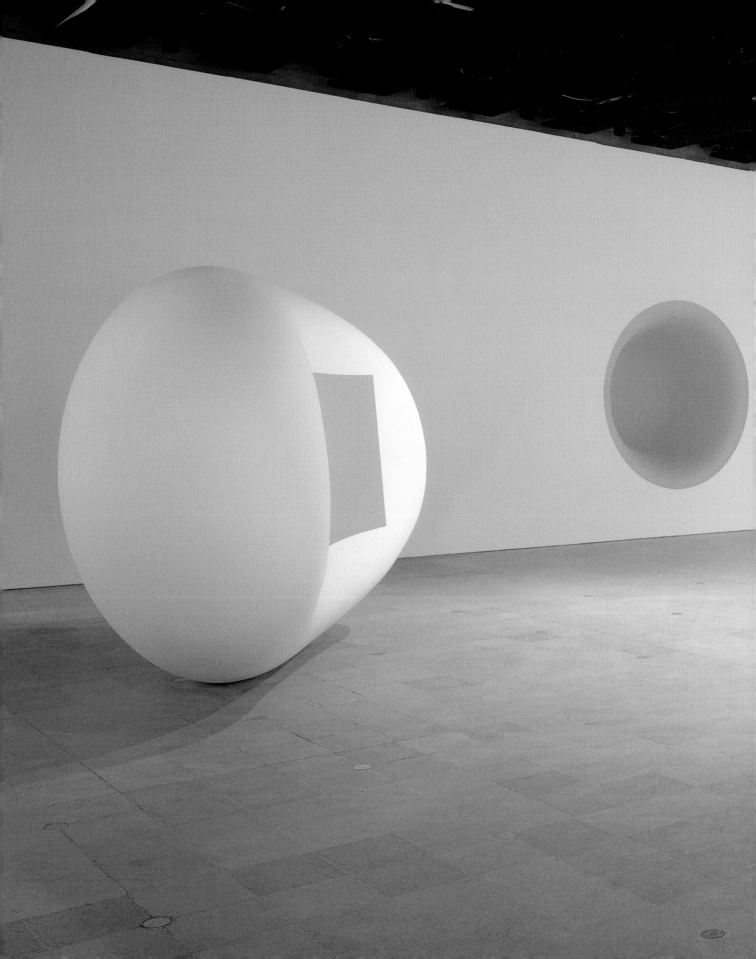

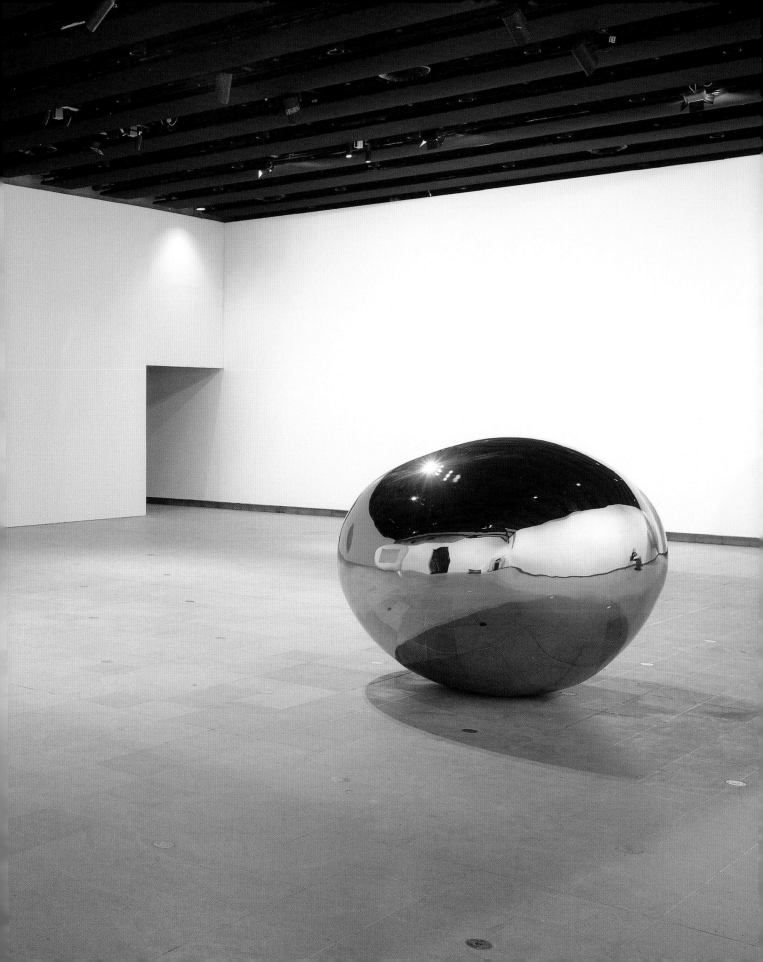

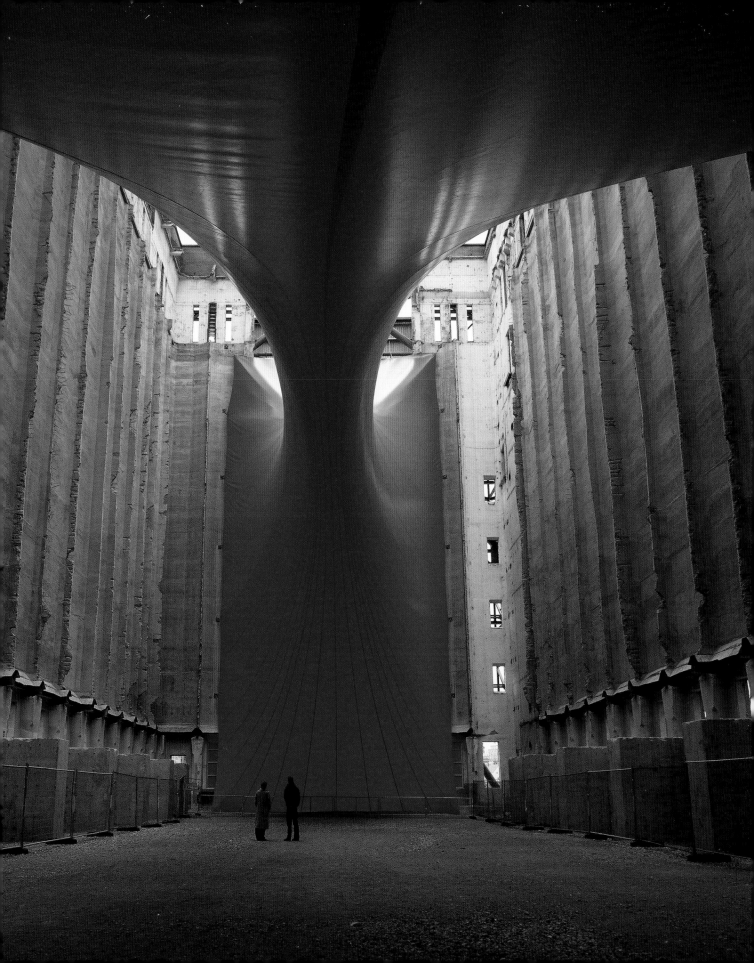

COLLABORATIONS, COMMISSIONS AND PROJECTS

Parabolic Waters, 1999
Millennium Dome, Greenwich, London

Sky Mirror, 2001
Public Square, Nottingham

This section documents all British commissions, collaborations and projects realised by Anish Kapoor to date. The list highlights the full spectrum of Kapoor's creative output and its reach beyond the gallery and into a range of public spheres, from human rights concerns to dance collaborations, monumental public art to therapeutic sensory experiences.

1993

Anish Kapoor designed an evocative sculptural stage set for *River Run,* a dance performance by Laurie Booth with music by Hans Peter Kuhn at the Queen Elizabeth Hall, London. The performance was followed by a regional tour.

Kapoor collaborated with the composer Brian Elias to produce *Echo,* a group of five sculptures with musical mechanisms.

1999

Gateshead Council commissioned Kapoor to create a work in the remains of the old Baltic flour mill, prior to its reconstruction as BALTIC Centre for Contemporary Art. It was in this setting, with the help of engineer Neil Thomason, that *Taratantara* was conceived. Kapoor commented, 'For many years I had been entertaining a fantasy of architecture, of building, as object. I was interested in thinking of the building in terms of a process of turning itself inside out.' Existing for eight weeks from 7 July to 1 September, the tensile structure was made from 50 metres of red PVC, forming a tunnel between two voids at either end of the derelict building. Aptly titled *Taratantara,* imitative of the sound of a trumpet call, the piece announced the new BALTIC to critical acclaim. As the writer and critic Richard Cork commented in the accompanying catalogue: 'It belonged to that site, and nowhere else. It was only meant to be temporary, seizing the moment when the battered BALTIC enclosed a tempting void. The beauty of *Taratantara* lay partly in its fleeting quality, and in our melancholy awareness that Kapoor's exhilarating summer intervention could not last.'

2000

As part of the Millennium Dome New Sculpture Project, Kapoor created *Parabolic Waters,* a structure containing a pool of coloured water rotating so as to create a smooth mirrored surface. The work was displayed outside the Millennium Dome in London.

2001

On 21 April, Nottingham Playhouse unveiled *Sky Mirror* – Kapoor's first permanent outdoor public work in the UK. Commissioned by Nottingham Playhouse and realised over a period of six years with funding from the National Lottery, this polished stainless steel concave disc has a diameter of six metres and weighs ten tonnes. It is angled towards the sky to capture the ever-changing urban environment outside the Playhouse.

2002

Kapoor collaborated with the dancer and choreographer Akram Khan and the composer Nitin Sawhney to create the stage set for *Kaash*, a touring dance production, which premiered in March in Creteil, France. *Kaash* – Hindi for 'what if' – explored aspects of the Hindu God,

Taratantara, 1999
BALTIC Centre For Contemporary Art,
Gateshead, 2000

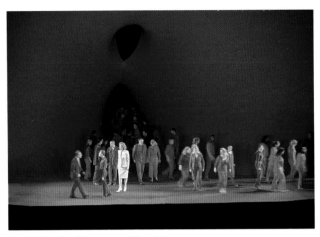

Set design for **Idomeneo**, Glyndebourne, 2003

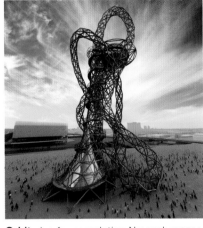

Orbit, due for completion November 2011
Olympic Park, Stratford, London

Shiva. Kapoor responded to the theme with an illuminated panel that changed colour to create a void on the stage.

Kapoor accepted an invitation from Tate Modern to create a work for the Turbine Hall, the third commission in the Unilever Series (9 October 2002–6 April 2003). Energised by the possibilities of this vast space, Kapoor created *Marsyas*, which, at 155 metres in length, became one of the largest interior sculptural works ever created. The installation was named after the satyr in Greek mythology who was flayed alive by the god Apollo after losing a musical competition. Realised with the technical aid of the renowned structural engineer Cecil Balmond.

2003
The beauty of *Marsyas* moved the Estonian composer Avro Pärt to write a new composition entitled *LamenTate*. Pärt then collaborated with Kapoor and the opera director Peter Sellars to stage a performance of the composition beneath the work at Tate Modern in February. Kapoor collaborated once again with the director Sellars and with the conductor Sir Simon Rattle on a seminal production

of Mozart's *Idomeneo* at Glyndebourne. In a review in *The Independent* in June, Edward Seckerson wrote: 'The director, Peter Sellars, and the designer, Anish Kapoor, meld like long-time collaborators For Anish Kapoor (in his first opera design) the juxtaposition is a livid red orifice, overtly, oppressively sexual, opening in the defining final act to an airy lightness and the sun coming out of eclipse.'

2005
As part of a solo exhibition at the Lisson Gallery, Kapoor presented an interdisciplinary collaborative sculpture, conceived with the author Salman Rushdie. The work, entitled *Blood Relations*, takes the form of two bronze boxes conjoined with red wax and inscribed around the outside with the first two paragraphs of Rushdie's text *Blood Relations, or an Interrogation of the Arabian Nights*.

2007
Kapoor was invited to contribute to a new group of artworks commissioned as part of a campaign to raise awareness of illegal

sex trafficking and to highlight the work of the Helen Bamber Foundation, a London-based charity. Devised by Emma Thompson and Sam Roddick, seven individually-curated transport containers were installed in Trafalgar Square under the title *The Journey,* representing the seven stages of suffering experienced by victims of sex trafficking: *Hope, The Journey, The Uniform, The Bedroom, The Customer, The Stigma* and *Resurrection*. Kapoor's piece, *Stigma*, was designed to highlight the void felt by victims of sex trafficking after disorientating and traumatic experiences. After seven days in Trafalgar Square in September, the project toured to various cities in the UK.

2008
In July 2008, Kapoor announced plans for the *Tees Valley Giants*, a series of five large-scale public sculptures to be sited in North East England over the course of ten years. The project acts as the public face of the Teesside regeneration project. Over the next decade the structures will appear within each of the Tees Valley boroughs: Middlehaven, Stockton, Hartlepool, Darlington and Redcar and Cleveland,

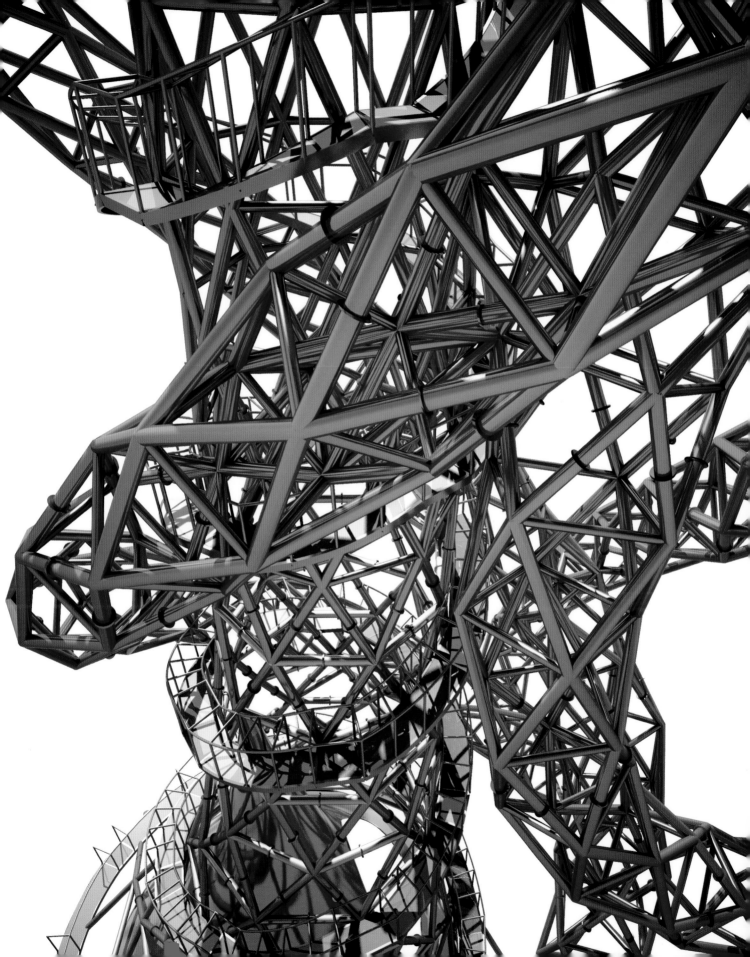

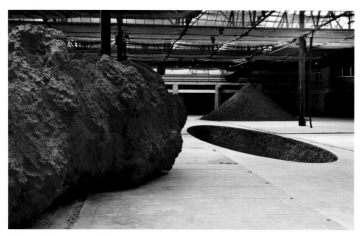

Dismemberment of Jeanne d'Arc, 2009
Old Municipal Market, Brighton Festival, 2009

Stigma, 2007
Journey project, Trafalgar Square, London, 2007

constituting the biggest public art project in the world.

Kapoor designed an innovative and emotive set for *in-i,* a dance performance arising from a unique collaboration between the dancer and choreographer Akram Khan and the actress Juliette Binoche, with music composed by Philip Sheppard. The performance took place against a wall of colour, which changed from red to orange, to yellow and green. *in-i* was staged in the Lyttelton Theatre at the National Theatre, London from 21 September to 6 October as part of an international tour.

2009

Kapoor was invited to become the Brighton Festival's first ever Guest Artistic Director. The Festival featured six major works by Kapoor installed in various venues across the city during May: *C-Curve* (2007), *Sky Mirror* (2009), *1000 Names* (1979–80), *Imagined Monochrome* (2009) – an installation combining light and massage, *Blood Relations* – the collaboration with Salman Rushdie, and a major new sculptural installation, *Dismemberment of Jeanne d'Arc* (2009).

Tall Tree and the Eye, a 15-metre high sculpture comprising 76 steel balls, was unveiled in the Annenberg Courtyard of the Royal Academy, marking the opening of Kapoor's major solo exhibition at the Royal Academy of Arts in London.

2010

The fruitful partnership between Anish Kapoor and Cecil Balmond found further recognition in March when it was announced that their proposal for the 2012 Olympic Games artistic centerpiece in Stratford, East London, had been successful. The proposed spiral tower structure will require 1400 tonnes of steel. *Orbit* is due for completion in November 2011.

The first of the Tees Valley Giants, *Temenos,* was unveiled in Middlehaven in June. *Temenos,* Greek for 'Sacred Ground', consists of 5.1 miles of steel cables suspended between two steel rings, 50 metres above the ground. Designed in collaboration with the engineer Cecil Balmond, this tensile structure again reveals a successful combination of engineering ingenuity and artistic inspiration.

September saw the launch of *Turning the World Upside Down*, a major exhibition of four large-scale outdoor sculptures in Kensington Gardens, which was commissioned by the Royal Parks and the Serpentine Gallery in London and curated by Hans Ulrich Obrist and Julia Peyton-Jones. Constructed from highly reflective stainless steel, the works forged new and unimaginable vistas of Kensington Gardens.

Sky Mirror, Red, 2009
Kensington Gardens, London, 2010

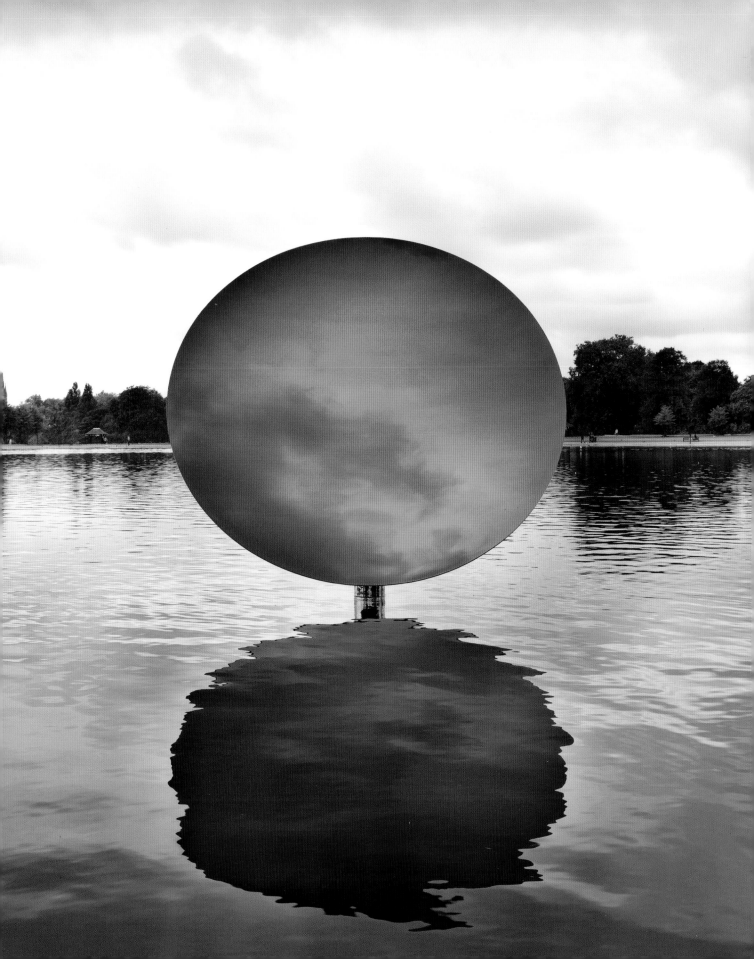

EXHIBITED WORKS

Not all works will be shown at each venue.
All dimensions are given in centimetres;
height × width × depth

Red in the Centre 1982
Mixed media and pigment
Dimensions variable
National Museums Liverpool,
Walker Art Gallery, purchased 1982

**White Sand, Red Millet, Many
Flowers** 1982
Mixed media and pigment
101 × 241.5 × 217.4
Arts Council Collection,
Southbank Centre, London,
purchased 1982

Adam 1988–89
Sandstone and pigment
239 × 120 × 104
Tate. Presented by the American
Fund for the Tate, courtesy of Edwin
C. Cohen (for A., A., A. and J.) 2000

When I am Pregnant 1992
Fibreglass, wood and paint
180.5 × 180.5 × 43
Courtesy of the artist
and Lisson Gallery

Void 1994
Fibreglass and pigment
110 diameter
British Council Collection

Turning the World Inside Out 1995
Stainless steel
148 × 184 × 188
Bradford Museums and Galleries.
Purchased with funding from the
proceeds of the National Lottery
through the Arts Council of England,
the Art Fund and The Henry Moore
Foundation, 1997

Untitled 1995
Stainless steel
140 × 92.6 × 100
Arts Council Collection,
Southbank Centre, London.
Acquired with assistance from
The Henry Moore Foundation, 1998

Her Blood 1998
Stainless steel and lacquer
Three parts, each 349 × 349 × 41.6
Tate. Purchased with assistance from
Tate Members, with funds provided
by the Estate of Father John
Munton, the artist, and Nicholas
Logsdail, 2003

Moon Shadow 2005
Wood, wax and oil-based paint
129 × 90 × 49
Courtesy the artist

Negative Box Shadow 2005
Wood, steel, fibreglass and wax
217 × 166 × 142
Courtesy the artist

Untitled, 2010
Wax, oil based paint and steel
135.5 × 135.5 × 222.5
Courtesy the artist

FURTHER READING

*Anish Kapoor: British Pavilion, XLIV
Venice Biennale*. Exh. cat., The British
Council, London, 1990. Texts by Thomas
McEvilley and Marjorie Allthorpe-Guyton.

Anish Kapoor. Exh. cat., Kunstverein
Hannover and The British Council,
London, 1991.

Anish Kapoor. Exh. cat., Tel Aviv Museum,
1993. Texts by Nehama Guralnik, Sara
Kitai, Wendy Kansky (texts in Hebrew &
English).

Anish Kapoor. Exh. cat., De Pont
Foundation, Tilburg, 1995. Text by Camiel
van Winkel (texts in Dutch and English).

Anish Kapoor. Thames & Hudson,
London, 1996. Text by Germano Celant.

Anish Kapoor. Exh. cat., Hayward Gallery,
London, 1998. Texts by Homi K. Bhabha
and Pier Luigi Tazzi.

Taratantara. Exh. cat., BALTIC Centre
for Contemporary Art, Gateshead, 2000.
Texts by Marjorie Allthorpe-Guyton,
Richard Cork, Richard Deacon, Sune
Nordgren, Michael Tarantino.

Anish Kapoor: Marsyas. Exh. cat., Tate
Publishing, London, 2002. Texts by
Donna de Salvo and Cecil Balmond.

Anish Kapoor: My Red Homeland.
Exh. cat., Kunsthaus Bregenz, Austria.
Texts by Eckhard Schneider, Thomas
Zaunschirm, Yehuda E. Safran.

Anish Kapoor: Whiteout. Exh. cat.,
Barbara Gladstone Gallery / Charta,
Milan, 2004. Text by Anthony Vidler.

Anish Kapoor: Melancholia. Exh. cat.,
MAC Grand-Hornu, 2004. Texts by
Laurent Busine and Denis Gielen.

Anish Kapoor: Drawings. Verlag der
Buchhandlung Walther Koenig, Cologne,
2005. Texts by Jeremy Lewison and
Laurent Busine.

Anish Kapoor: My Red Homeland.
Exh. cat., CAC Malaga, 2006. Texts by
Fernando Frances and Angela Molina.

Anish Kapoor: To Darkness: Svayambh.
Prestel, London, 2008. Texts by Rainer
Crone and Alexandra Von Stosch.

Anish Kapoor: Past, Present, Future.
Exh. cat., The Institute of Contemporary
Art, Boston / MIT Press, 2008. Texts by
Nicholas Baume, Mary Jane Jacob,
Partha Mitter.

Anish Kapoor: Memory. Exh. cat.,
Deutsche Guggenheim, Berlin /
Guggenheim Museums Publications,
2008. Texts by Henri Lustiger-Thaler,
Sandhini Poddar, Gayatri Spivak, Steven
Holl, Christopher Hornzee-Jones.

Anish Kapoor: Shooting Into The Corner.
Exh. cat., Osterreichisches Museum für
Angewandte Kunst / Hatje Cantz Verlag,
2009. Texts by Peter Noever, Michael
Stavaric, Bettina M. Busse, Vito Acconci,
Gabriel Ramin Schor, Burghart Schmidt,
August Rhys.

Anish Kapoor. Phaidon, London, 2009.
Texts by David Anfam, Johanna Burton,
Donna De Salvo, Richard Deacon,
Matt Price.

*Anish Kapoor: Unconformity and
Entropy*. Turner Ediciones, Spain, 2009.
Texts by Anish Kapoor, Adam Lowe and
Simon Schaffer.

Anish Kapoor. Exh. cat., Royal Academy
of Arts, London / Thames and Hudson,
London, 2009. Texts by Homi K. Bhabha,
Jean de Loisy, Norman Rosenthal.

*Anish Kapoor: Turning the World Upside
Down*. The Royal Parks, London /
Serpentine Gallery, London / Koenig
Books, 2010. Texts by Julia Peyton-
Jones, Hans Ulrich Obrist, Anish Kapoor,
Darian Leader, Marcus du Sautouy,
Stephanie Dieckvoss.

Anish Kapoor: Delhi, Mumbai. Exh. cat.,
British Council / Lisson Gallery, 2010.
Texts by Greg Hilty, Andrea Rose, Anish
Kapoor, Homi Bhaba, Nancy Adajania.